TRANSPARENT WATERCOLOR

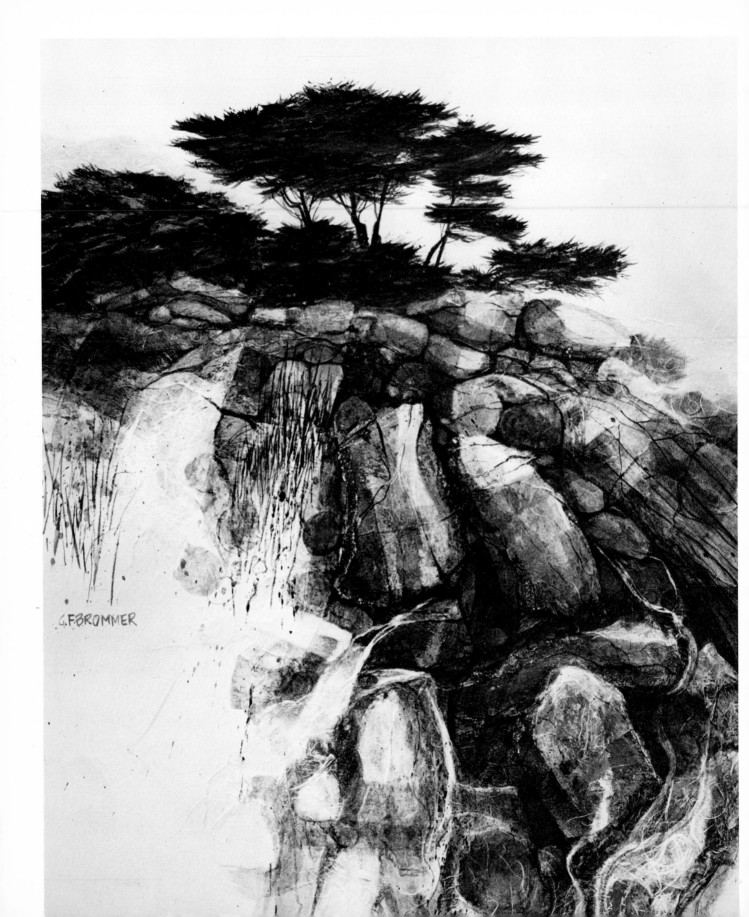

Davis Publications, Inc.

Worcester, Massachusetts

Gerald F. Brommer

Art Teacher, Lutheran High School
Los Angeles, California

TRANSPARENT WATERCOLOR:
ideas and techniques

Picnic. *Robert E. Wood, transparent watercolor, 22 x 30.*

Title Page Illustration: Detail of *Carmel Series, No. 12 / Lonely Coast.*
Gerald F. Brommer, watercolor and collage on watercolor board,
24 x 36. Detail covers area about 20 x 18. Collection of Dr. John P.
Glathe. Photograph by Nils Ibsen.

Copyright 1973. All rights reserved.
Davis Publications, Inc.
Worcester, Massachusetts, U. S. A.
Printed in the United States of America
Library of Congress Catalog Card Number: 72-97154
ISBN 0-87192-054-9

Printing: Halliday Lithograph Corporation
Type: 9/11 Optima, set by Thomas Todd
Graphic Design by Author and Panagiota Darras

Consulting Editors: George F. Horn, Sarita R. Rainey

TO GEORGIA

Other books by Gerald F. Brommer
Wire Sculpture and Other Three Dimensional Construction
Relief Printmaking
Drawing: ideas, materials and techniques

CONTENTS

1 TRANSPARENT WATERCOLOR: AN APPROACH 8
Where It All Began / How It Has Progressed / What
Transparent Watercolor Is / What Transparent Watercolor
Is Not

2 TOOLS AND MATERIALS 18
Brushes / Paints / Papers / Mixing Trays, Water Containers
and Working Surfaces / Other Tools, Materials and Surfaces

3 DESIGN AND COMPOSITION 28
The Parts of a Painting / Some Things to Do / Some Design
Concepts / The Search for a Personal Style / The Liquid
Line / Value: The Dark and Light of It / Color: Some Notes /
Emphasis: The Center of Interest / Movement and Action

4 BASIC TECHNIQUES 46
Wash Drawing as Introduction to Watercolor / Using the
Brushes / Emphasis on Water / Ways to Start a Watercolor /
Using Washes / Line and Drybrush / Using a Loaded Brush /
Using the White of the Paper / Soaking and Flooding / The
Wet-In-Wet Techniques / Other Techniques / Making
Corrections

5 COMBINING TRANSPARENT WATERCOLOR WITH
OTHER MATERIALS 66
With Crayon or Wax / With Starch and Glue / With
Turpentine / With White Tempera / With Collage / With
Inks and Stains / With Stop Outs / With Other Media / On a
Different Surface

6 HELPS IN PAINTING 80
Skies and Clouds / Water / Trees and Foliage / Hills and
Mountains / Rocks / People / Buildings / Still Lifes /
Animals and Birds / Abstractions

7 WHERE TO LOOK FOR SUBJECT MATTER 98
Photographs / Sketchbooks / Poetry and Imagination /
Painting Outdoors / Still Lifes and Models

8 HOW SOME WATERCOLOR ARTISTS EXPERIMENT 108
Lee Weiss / Win Jones / Nick Brigante / Gerald F. Brommer /
Keith Crown / Jo Liefeld Rebert / Alexander Nepote /
Morris J. Shubin

9 SOME FINAL THOUGHTS 118
Problems and Assignments / Signing, Matting and Framing /
Other Aids / Watercolor Books that Can Help

Index 126 Acknowledgments 128

COLOR SECTION following page 40

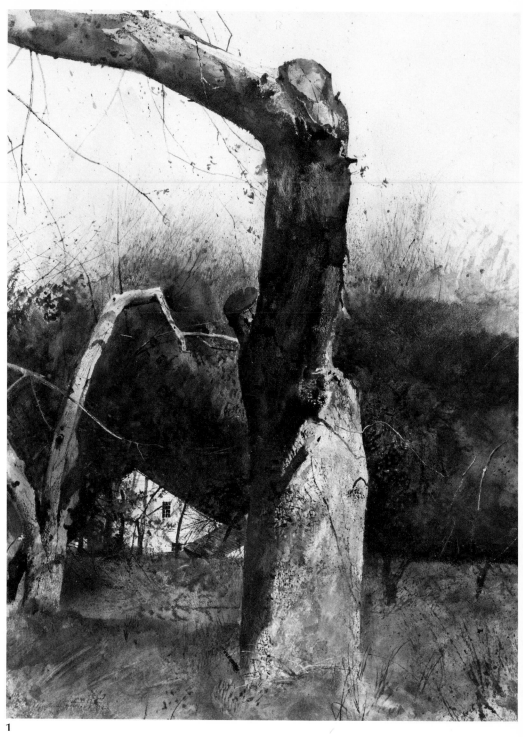

1

1 Early Spring. *Andrew Wyeth, watercolor, 30 x 22. Courtesy of the Los Angeles County Museum of Art, Gift of Maurine Church Coburn.*
2 Early Morning — Concarneau. *Donald Teague, watercolor, 20 x 30. Private Collection, Courtesy of the artist. Photograph by Robert Singhaus.*

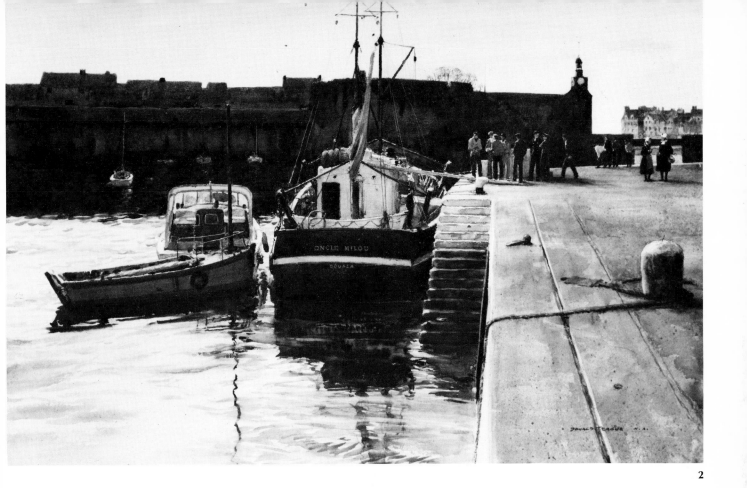

BEFORE BEGINNING

I just now walked away from my easel. I'm working on a water-color painting of a farm in the Tuscan Hills of Italy. Early morning. Rocks, grapes, grass, old buildings and the white sun charging through a misty morning. It's a feeling, not a place. I've painted, collaged and repainted several times, and the painting is beginning to work. It is an exciting process and I love the entire work cycle from beginning to end.

I didn't always paint transparent watercolor with the technique I'm presently using — not many painters do. Perhaps my next painting won't have any collage at all. It might be done on a gessoed panel and have a completely different feel. This very versatility is the challenge of transparent watercolor. And it is this changing, dynamic and versatile quality of the medium that this book will attempt to portray.

I like looking at pictures, feeling that I learn more from them than from pages of words. So, I've filled the book with photographs of paintings, hoping that you and your classes will learn from them. I tried to keep the word content to a minimum, but for a long-time teacher, that is almost impossible. The pictures tell the story, illustrating the fascinating variety of transparent watercolor. From the pictures and their captions, you should be able to draw many lessons and set up a multitude of assignments.

Students, artists and museums have helped illustrate the book. The artists (many of whom I can happily call my friends) are among the best in the country, and many of the works they show here have won prizes in exhibits all over America. You are looking at the best! And they epitomize the stimulating variety of the medium.

Many books tend to promote a single point of view, a single artist's work, or a how-to-do-it approach. I have rather tried to show that the excitement of watercolor is in its diversity and adaptability, using many artists and many approaches. I don't prescribe any single way of producing a painting, but rather encourage a search and discovery system based on the fantastic array of work found between these covers.

No lesson plans are proposed, no sure-fire step-by-step procedures are presented. You can buy other books that will help you there. But here are hundreds of ideas to turn water-color classes into high adventure — to help in the exploration and discovery processes. And that is what art teaching is all about.

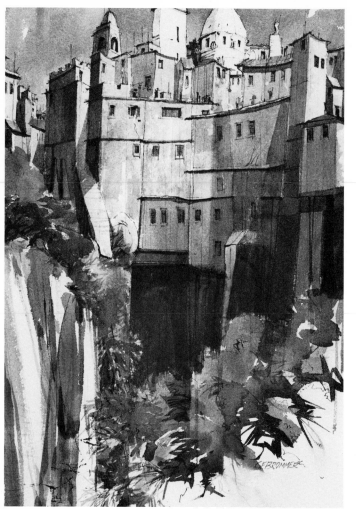

THERE IS PROBABLY no medium that is more controversial than transparent watercolor. It is misunderstood by many, derided by some, but defended to the death by its adherents. It has divisions within the ranks of its supporters — purists on the one hand and experimenters on the other. But in this very tension exist the seeds of excitement.

Transparent watercolor is sometimes awesome in its complexity, and this often promotes timidity in its application. But there is also an incongruous strength apparent in this aqueous and transparent medium. It is actually very easy to apply to paper, but difficult to control at times. It can appear wet or dry, thin or thick, pure or mixed. It has been called the medium of the masters, and yet it is offered to kindergarten classes for daily use. It is fun and work, difficult and easy.

In the classroom, how will you approach this medium? What do you offer as motivation? Which of the many directions do you take? The answer, of course, is not universal. With so many options, there certainly isn't "one best way" to go.

The wide selection of techniques offered in this book will help teachers and students pick some direction. We should be familiar with the basic methods before experimentation takes place, but there is absolutely no need to hold back the exploration and discovery process. Get the washes and color mixing out of the way. Spend a few days with quick and simple problems to get familiar with the medium and its possibilities, and then jump into the excitement and stimulation of transparent watercolor.

We don't want to belittle fundamentals, because they are basic to good craftsmanship. But we also do not want to cripple the desire for exploration with *too many* periods of exercises and required color swatches. A good balance in this regard is essential to foster enthusiasm for the medium.

Don't harp on the difficulties and technical problems of the medium, but rather on its spontaneity and fascinating happenings. Keep a positive attitude regarding exploration. It is definitely one of the most exciting painting mediums to work with, and that feeling should carry into the classroom.

Its familiarity ("we did that already in first grade") is perhaps a drawback, but watercolor's possibilities have not begun to be explored in our classes. Motivation cannot come from the newness of the medium, but must come from the challenge of exploring new possibilities. It must be a "try it and see what happens" attitude (this is where creativity develops) not one of following a complex set of rules.

1 TRANSPARENT WATERCOLOR:
AN APPROACH

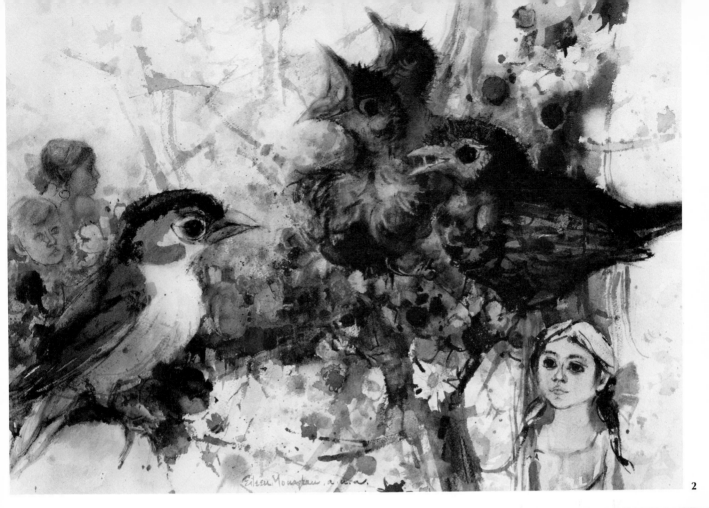

2

Transparent watercolor is fluid and your approach to it must be fluid also. Allow for a vast range of possibilities, but try to keep the spontaneous and exciting atmosphere of the medium itself alive in the classroom. Student work is really only exploration into the medium, not the search for masterpieces. Let them feel the exhilaration of discovery, the letdown of missed opportunities. The search is the important aspect of transparent watercolor, as in all art at the secondary level. Craftsmanship should be praised; sound design should be commended. Most of all, inquisitive searching should be lauded.

3

4

1 Hilltown Pattern. *Gerald F. Brommer, watercolor and ink, 22 x 15. Broad washes are combined with crisp ink lines that sometimes outline and sometimes noodle away on their own. Courtesy, Fireside Gallery, Carmel, California.*
2 In the Treetops. *Eileen Monaghan Whitaker, watercolor, 22 x 30. Youngsters and birds are put together in a unique approach to the subject matter. Brightness and activity give it bountiful life. Courtesy of the artist.*
3 *Free and rapid execution followed several days of investigating sea shapes and textures. Look for shells, sun, water, sails, people and fish. Watercolor and ink, 8 x 24. Paul Revere Junior High School, Los Angeles.*
4 *The juicy application of watercolor is given a crisp look with the addition of black India ink lines. Student model sits in the still life set-up. Work is 30 x 24. John Marshall High School, Los Angeles.*

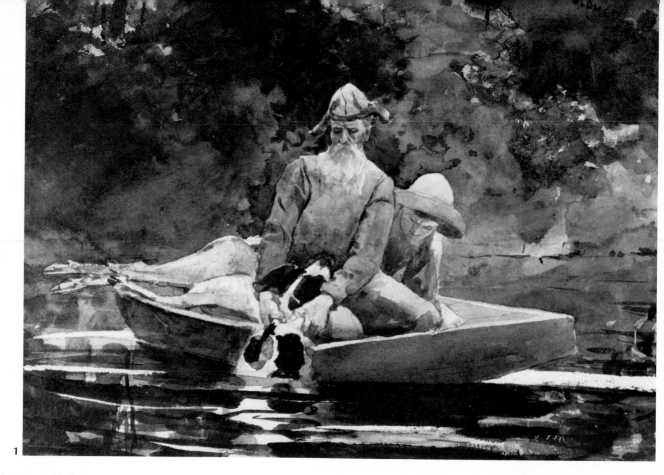

1 After the Hunt. *Winslow Homer, 1892, watercolor, 18 x 24. Homer was a master of watercolor, as this painting shows. He brushed, scratched, scraped and even ripped the white area at right of the paper, but always under complete control. He was the first American to publicly say that his watercolors were more important than his oils. Courtesy, Los Angeles County Museum of Art, Paul Rodman Mabury Collection.*

2 September Glade. *Charles Burchfield, watercolor, 33 x 23. This great American artist was one of the earlier proponents of the watercolor medium in this country. His expressionistic and personal landscapes are unique in the history of the medium. Collection of Concordia Teachers College, Seward, Nebraska.*

3 The Magi. *Giovanni Guercino (1591-1666). Pen and bistre wash. Typical of Renaissance wash drawings, the washes generalize the forms while the pen line delineates detail. Notice the leaving of light paper to produce the white. The Metropolitan Museum of Art, New York, Rogers Fund, 1908.*

4 The Hideous Woman. *Georges Rouault, 1918, watercolor and gouache, 12 x 7¹/₂. The artist's characteristic heavy line is also employed in his watercolor technique. Courtesy, Los Angeles County Museum of Art, Gift of George Keller.*

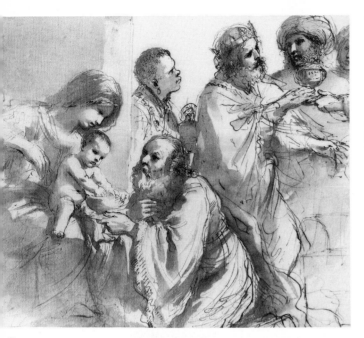

3

4

Where It All Began

Waterbased media are among man's oldest painting substances, dating back to the cave walls of Altamira, Lascaux and the Sahara. Egyptian scribes diluted color in water, added a binder and tinted their wall illustrations. Medieval manuscripts were given life with passages of water soluble color. The mysterious Etruscans decorated their tombs and urns with a fantastic array of animals and plants, all done in a watercolor of sorts. Roman and Byzantine artists produced tempera by adding egg to their mixtures, and painted on wooden panels. But the greatest contributions to the transparent medium came from the Orient.

As early as the 8th century A.D. Nara Period, the Japanese were painting on paper with diluted inks, being influenced by contemporary Chinese, Indian and Korean developments. Sumi-e painting is a distinct art in itself, but its controlled spontaneity is an essential ingredient in watercolor techniques, and a forerunner of later developments.

Renaissance artists, however, were responsible for the renewed interest in watercolor because they used it as a sketching medium prior to making larger oils. It had become a spontaneous and colored extension of the drawing process, a sort of colored shorthand.

Albrecht Dürer thought of watercolors as finished products — not only preliminary sketches. Rembrandt and Tiepelo added to this importance with vibrant and stimulating works. In France, Delacroix used the medium to add a feeling of immediacy and action to his rapidly stroked sketches.

A method of using watercolor without opaque materials was developed by Paul Sandby in England in the 18th century and was called aquarelle. Prior to this time, lighter values were achieved by adding opaque white color, now the white of the paper became part of the medium, and transparent watercolor was born — in England.

William Blake and William Turner got things rolling a bit later, giving transparent watercolor its dynamic impetus. Watercolor clubs and societies were formed to aid in exhibiting artists' works, because the medium was still (early 19th century) considered a sketching material, and not as important as oils.

In the latter part of the 19th century, American Winslow Homer's series of Bahama paintings pumped increased zest into aquarelle. Other Americans followed: Prendergast, Sargent and Demuth in the 19th century, and Feininger, Marin and Burchfield in the 20th.

French Impressionists and Post Impressionists made extensive use of watercolor, with Cézanne particularly making vast contributions to the development of the medium. The Expressionists also found the immediacy of watercolor an asset in putting their feelings on paper.

Contemporary transparent watercolor has a legacy that extends back in history to the near beginnings of time and it is important to know how we fit into the continuum, but it is what is happening NOW that is fascinating. Some of that ex-

citement can be found in this book, some in museums, some in the excellent shows of the American Watercolor Society and the California National Watercolor Society, or area watercolor exhibits such as Watercolor West in Logan, Utah, or Watercolor U.S.A. in Springfield, Missouri.

How It Has Progressed

"Charming landscapes done in watery pastel colors" seems to be the impression most people have when hearing the term "watercolor." Although the medium is transparent, it need not be watery or weak. Today's artists work on paper with energy and strength, when it is called for, to produce dynamic paintings. Of course, softness and subtlety are equally important at times, and the medium adapts to those requirements.

Styles of working the surfaces are as varied as the number of excellent artists applying aquarelle to papers. Design, color, forms and surfaces can vary. So can subject, treatment, approach and outcome.

Tricky experiments are not necessary to vary the results. Look at the examples on these two pages, all work by renowned watercolor artists. Or glance through chapter 8 which shows some pretty exciting styles and variations in technique. All are stimulating and vibrant expressions of artists eager to communicate through the transparent medium.

Your own work can convey similar excitement if you carefully explore the possibilities presented in this book — splash away on some of your own variations.

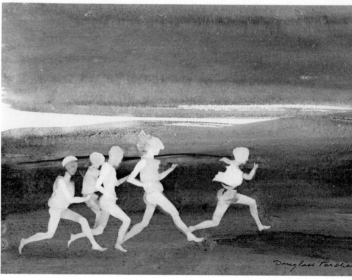

1. Fisherman's House, Patzcuaro. *Millard Sheets, watercolor, 22 x 30. Luminous watercolor surface is given added vibration with application of dots in pointillist-like patterns. Shapes are strong in their simplicity, adding to the rugged feeling. Private collection.*
2 Race. *Douglass Parshall, watercolor, 15 x 22. Beautifully luminous washes cover the surface while ghost-like images seem to float over them. The stopped-out figures are touched with washes to give them slight solidity. Springfield Art Museum, Missouri.*
3 Fragmented Society. *Al Porter, watercolor, 22 x 30. (From Kennedy Assassination Series.) Handsomely expressive shapes, in bold dark and light, interact to give the desired fragmented feeling. Strong design produces a powerful composition. Collection of the artist.*
4 Big Sur Moment. *Phil Dike, watercolor and ink, 22 x 30. Dynamic strength of the rocks and the fluidity of the water are contrasted in this painting. The artist has designed the area with knowledge and care, yet it seems absolutely spontaneous.*

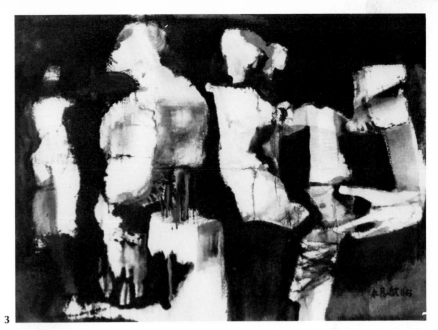

3

4

What Transparent Watercolor Is

Only when greatly diluted with water, are "transparent" colors really see-through. Slightly diluted they appear translucent and when applied with little or no water, they are nearly opaque. But the term "transparent watercolor" is used to differentiate the paints from those with definite opaqueness. The latter use opaque white to make the colors lighter, and are known as gouache, casein, tempera and show card paint. Transparent watercolor uses no white paint, but uses the white of the paper as part of the medium. Lighter tints are obtained by thinning the color with more water, allowing the white paper to lighten the hue.

Acrylic paint may be used in either way, transparent (when thinned with medium or water) or opaque (when unthinned). Generally what is said in this book about transparent watercolor also may apply to thinned and transparent acrylic paint.

Transparent watercolor then is a method as much as a material. It is a method of painting that allows the white of the paper to sparkle through the applied color. A method of putting down layers of overlapping colors like sheets of stained glass. This overlapping and see-through quality is what gives watercolor its unique depth and sparkle. The running, watery, transparent, overlapping and sparkling effect is the special feel of watercolor.

1 Forest Aflame. *Roger Armstrong, watercolor, 22 x 30. Marvelously fluid colors run and blend in some parts of the painting while crisp branches are scratched out when wet or brushed on when dry. Laguna Beach Art Museum, California.*
2 Shipyard, Port Angeles. *Phil Austin, watercolor, 21 x 28. Sunlight and shadow dominate this work, even though two ships form the subject matter. Broad washes comprise most of the painting, with a minimum of thin lines added. Collection of St. Luke's Hospital.*
3 Collinsville. *Michael W. Green, ink and watercolor, 22 x 30. The artist uses ink washes for building up values and then applies watercolor washes over them to give limited color. Value contrasts are very strong but transparency is still evident. Notice the simple board patterns. Courtesy of the artist.*
4 Alamos Rehabilitation, Mexico. *Ralph Hulett, watercolor, 22 x 30. Close-ups of buildings require graphically textured surfaces which are accomplished here with spattering, dry brush and glazes. Street seems extremely bright compared to middle valued walls. Note the very simple but effective doorway treatment. Courtesy of the artist.*

1

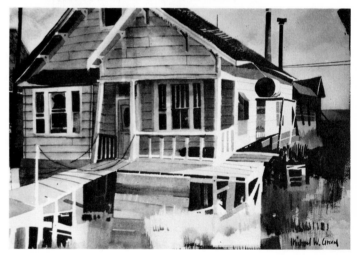

3

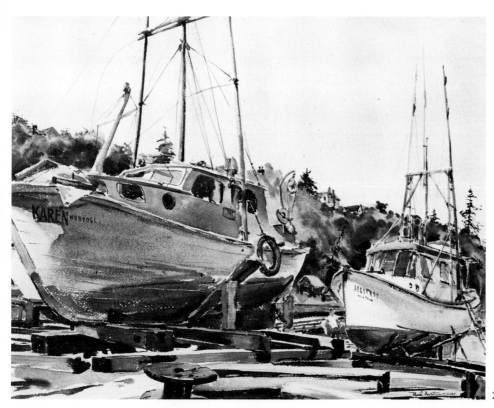

2

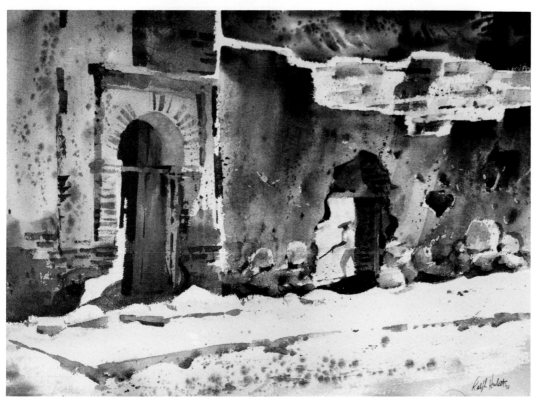

4

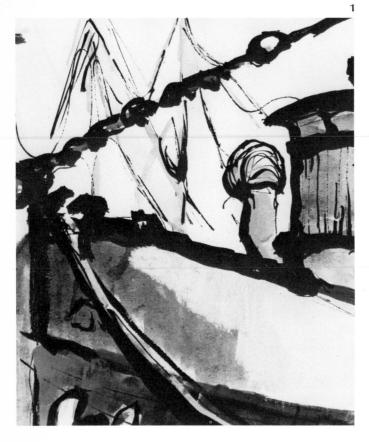

1 *Detail of a gouache painting by Reinhold Marxhausen shows the way that lighter values can be placed over darker values in paintings that are opaque. This could not be done if all colors were transparent. Collection of the author.*

2 *Detail of a painting by Ray Jacobsen which uses opaque watercolors You can see that the colors run and that washes are employed, but the white and light values have been applied over darker colors. Collection of the author.*

3 *Sausalito People (detail). Robert E. Wood, watercolor, 15 x 22. This is watercolor: simplification, accidental running, dark against light, light against dark, large brush strokes, minimum detail, good value contrast, abstract patterns of dark and light. Courtesy of the artist.*

4 *Four basic water-based media can be compared as to their transparency. Acrylic, casein and tempera, in thicker parts of the display, show complete opacity, while the transparent watercolor can be seen through even while applied heavily. The casein and tempera appear chalky when thinned, while the acrylic and transparent watercolor are very transparent when thinned. Lines under the paints are simply made with pencil.*

5 *Facade, St. Gilles. Gerald F. Brommer, watercolor, 15 x 30. Value contrasts are important to show depth of portals, but notice the sculpture. No white or opaque colors were added. The sculptural figures were left light and spaces around them were darkened with washes. Collection of Mr. and Mrs. John Gorman.*

What Transparent Watercolor Is Not

Building from light to dark is the general practice in working with aquarelle. Light colors go on first, with the whites protected — unpainted. Medium and darker values are brushed on as the painting proceeds, until the ultimate darkest value is laid on. This method allows for little or no lightening of areas at a later time (although that may be done in a number of ways).

Opaque watercolors can be worked from either light-to-dark or dark-to-light because areas can be painted white or lightened at will. When we discuss transparent watercolor in this book, we will not be considering all watercolors or water soluble media, only transparent, and worked in ways that enhance the medium's transparency. Tempera, gouache, casein and heavily applied acrylic paint are not transparent by their nature. They may be extremely thinned with water to become nearly transparent, and can produce beautiful effects of their own. But they are not transparent.

In some experimental processes explored in this book the end result may not be transparent, even though transparent colors were used as pigment. These are stimulating experiments and are profitable in understanding the range of uses of the medium. What follows is a discussion of the uses and explorations possible with transparent watercolor — the kind that comes in pans or tubes and produces pure transparent areas when brushed on white paper.

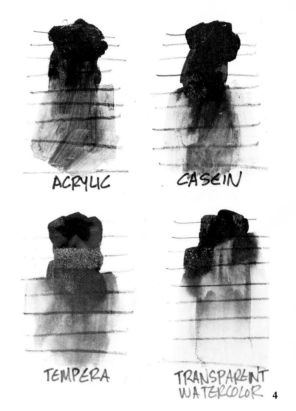

ACRYLIC CASEIN

TEMPERA TRANSPARENT WATERCOLOR 4

5

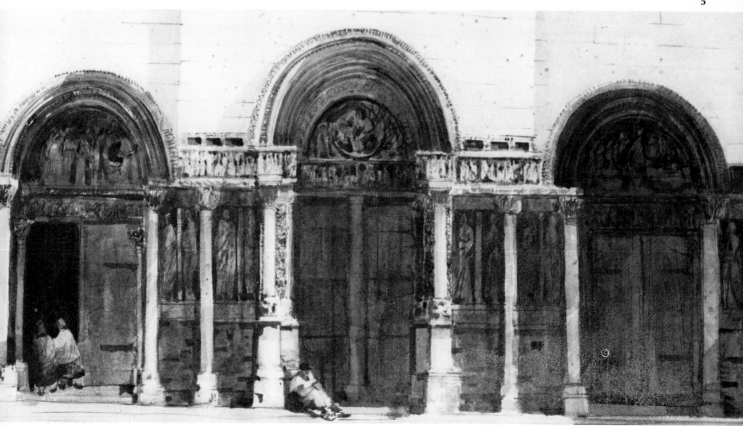

BASIC WATERCOLOR EQUIPMENT consists of brushes, paint and paper. Of course, you must add a container for water, a pan to mix paint, pencils, sponges and some other items. But the basics are easily available and can be relatively inexpensive. Prices range from very cheap to very expensive for all the necessary items. Your budget will help determine the quality of your tools and materials. Check out several art supply catalogs and notice the wide range of costs.

Brushes

No single brush is "best" and experimentation will provide the one most suited to your method of work. Use the largest one possible for the job at hand — steer clear of very little ones.

Round brushes range in size from No. 000 (smallest) to No. 16 and come in a variety of types. Best (and most expensive) are made of red sable which, regardless of size, will come to a very fine point when wet, and will remain resilient for hours of work. Ox hair or sabeline brushes are excellent for school use, as they will remain springy for extended work periods. Sabeline is really a dyed ox hair brush. Camel hair brushes (or squirrel hair) are very inexpensive and relatively useless, since they fail to hold their shapes when saturated for a time.

Flat brushes are the favorite of many artists, even though the round ones are thought to be the traditional watercolor brush. They range in size from 1/8 inch to 2 inches wide and also come in red sable, sabeline or ox hair. Some teachers use only 3/8 inch flat brushes, others allow a wide selection for student use. It's up to you.

Japanese brushes are double ended, or often come with quill pens on one end. They don't hold shape very well, but come to needle sharp points and are excellent for producing thin lines. They should be held upright, in the traditional Japanese writing position, for best results.

Bristle brushes, the kind usually used in tempera or oil painting, can also be used with watercolor. They are stiff, usually large, and are excellent for boldly laying down initial colors or for dry brush techniques.

Stencil brushes, tooth brushes and *varnish brushes* can be used for special effects or for experimental purposes. As with most of the artist's equipment, a bit of exploratory work will determine the best brushes for the job, with the budget providing another limitation.

1

3

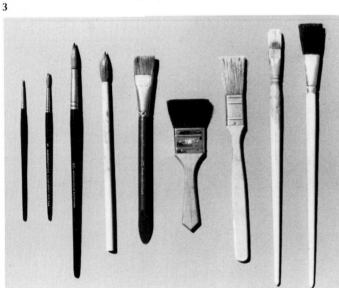

2 TOOLS AND MATERIALS

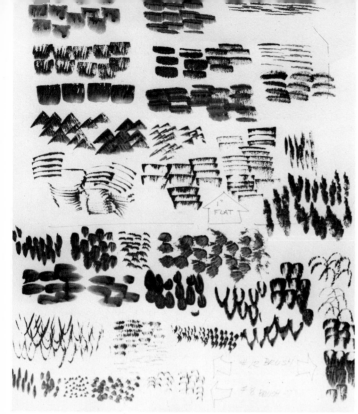

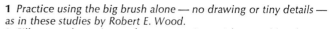

1 *Practice using the big brush alone — no drawing or tiny details —
as in these studies by Robert E. Wood.*
2 *Fill pages of practice strokes or stampings with several brushes to
determine possible uses for each.*
3 *Possible brushes for watercolor use include: No. 1 sable, No. 5
sabeline, No. 12 sable, Japanese brush, 1" flat sable, 1½" soft wash
brush, 1" varnish brush, No. 8 bristle brush, and 1" black bristle brush.*
4 *Try holding watercolor brush in several positions and also try using
different parts of it, like the tip, side, heel or handle.*
5 *Entire painting of a simplified leaf and branch shapes was done with
a single brush, a ³⁄₈" flat watercolor brush. Work is 24 x 18 inches
on drawing paper. Reseda High School, California.*

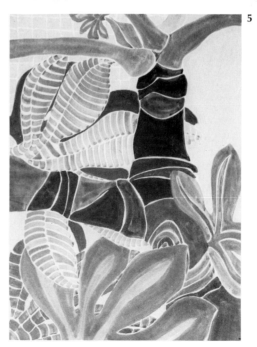

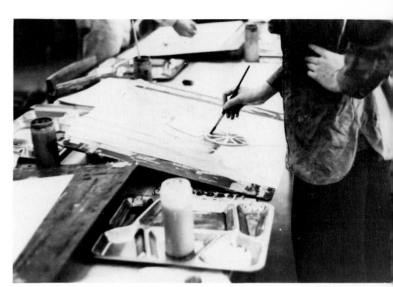

All brushes should be cleaned carefully each time they are used. They simply last longer and don't introduce unwanted colors into the next painting. Wash them thoroughly under a faucet or use mild soap and water and wash in the palm of your hand. Shake out most of the water, but don't squeeze the brushes firmly between your fingers — let them shape themselves or gently coax them to points. Don't let them stand on the bristles when drying. Brushes are your major tool, so it makes sense to take good care of them.

Paints

When selecting watercolor paints, you again run into the matter of dollars and cents. The best paints are expensive and brilliant, while the type a school can afford are not of the same high quality. The better pigments are more permanent and usually come in tubes. Most classrooms come equipped with boxes of watercolors, containing eight or more pans of color, and probably an inadequate brush.

Tubed colors come in a fantastic array of hues and the artist must choose those that most suit his subject and work. This choosing process can take many months of experimentation; and the artist's palette, as his selection of colors is called, becomes a very personal thing. Art teachers, because of the cost involved, don't have to worry about this selection. But they must decide on which watercolor sets to order. These sets vary in the size of the color pans (full pan or half pan) and also in the number of colors available (8, 12, 14, 16, 21, 24, 36, or 180!?!). The most economical are the eight-color sets of half pans. Refills are available for them and alternate colors can be chosen to replace or add to the sets. Almost all student work in this book was done with these eight-color sets.

Mixing these eight colors can produce an almost infinite variety of hues. If you don't like certain colors in the set, order half pan refill alternates, and insert them in the sets. Students should realize that most artists use a relatively small number of colors in their palettes, even though many dozens are available. Excellent paintings can be produced with the eight colors in the pans, since they represent the primary colors (red, blue, yellow) and the secondary hues (orange, green and violet), with brown and black added. The colors might not be desirable in themselves, but when mixed and remixed with others in the set, they become quite acceptable.

1

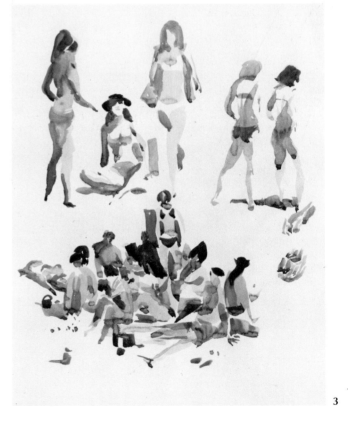

3

20

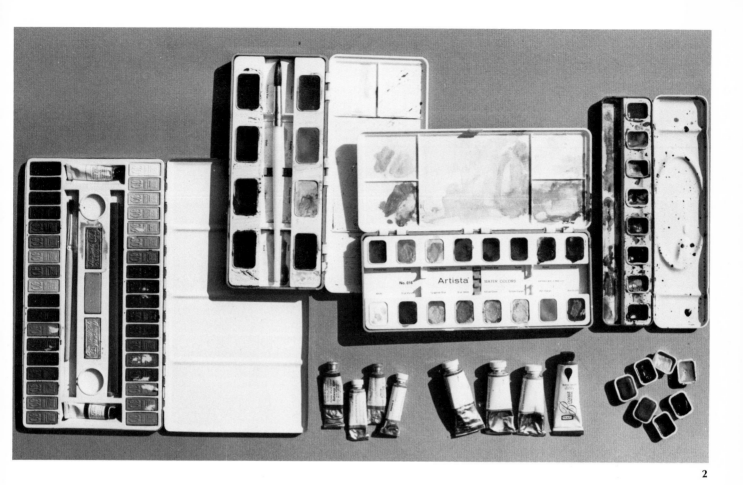

Because pan colors are quite dry, you should always put a few drops of water on each of them several minutes before starting to paint. This will make them moist and will allow brushes to pick up color easily, thus eliminating the scrubbing process in the pans. If tubes are used, paints can be squeezed directly onto the mixing tray and are ready to go.

Transparent watercolor uses gum arabic as a binding agent, adhering the pigment to the paper. Since this binder is resoluble in water at any time, the finished painting must be protected from unwanted water or dirt — usually with a sheet of glass, if the painting is framed.

1 *Initial brushed-in shapes can be done rapidly with large bristle brush and lots of water and color. Don't be timid, brush boldly.*
2 *Several choices await the watercolorist when he begins to pick his colors. Set of many small color blocks on the left, then 8 color full-pan set, 16 color half-pan set, 8 color half-pan set, small tubes, large tubes and half-pan refills. Notice the mixing area for washes is quite small, especially in 8 color sets.*
3 *Learn to use colors and brushes freely and simply, and don't fret with tiny details. Robert E. Wood deftly put these figures down from direct observation — with values only and not with line. Sheet is 24 x 18 drawing paper. Courtesy of the artist.*

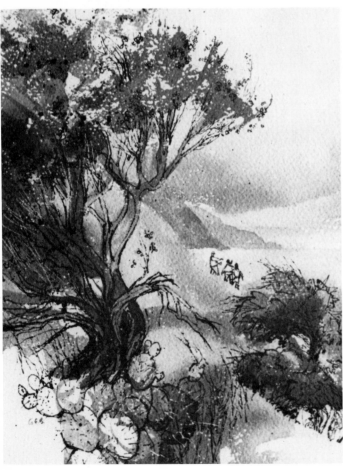

Papers

As with brushes and paints, watercolor papers vary a great deal in cost and quality. Paper is the traditional ground for watercolor painting, and the best (and most expensive) papers are hand-made of linen rag in Europe. England, France and Italy produce the best, with American machine-made papers seeming to lack the quality most artists seek. These excellent papers come in surfaces that vary from smooth (hot pressed) to medium rough (cold pressed) to rough. The general size is about 22 by 30 inches, though special sized sheets are available. The weight or thickness of the paper also varies from 72 lb. which is light and flimsy to 400 lb. which is thick and heavy. (The poundage of paper is figured by how much a ream of 500 sheets weighs.)

Thinner papers are often stretched to provide a non-wrinkling surface. This is done by soaking the paper, spreading it on a board and fastening the edges either by stapling or securing with paper tape. When dry, the surface won't wrinkle when water is poured or brushed on the paper.

These expensive papers are not suitable for class work because of cost. Many American companies supply student grade watercolor papers that should be tried by teachers to check the quality and absorbing properties. Surfaces vary with the companies as do the weights of the sheets — both important considerations.

Other papers, not specially prepared for watercolor painting, are often just as suitable for school use. They can all be tried. Oatmeal and heavy white drawing paper have fine absorbing qualities. The back (smooth) side of charcoal paper can be used. No paper should be ruled out until it has been tried. What watercolor does on smooth hard surfaces is fascinating, and what it does on rough absorbent ones is also fascinating. Even rice paper or cotton cloth can provide surfaces for exciting watercolor experimentation.

If you think student grade watercolor papers are too hard or too textured, try alternate papers. None of the classroom papers are as permanent as imported papers, so all are possible grounds for your paintings. If you want to work large, try butcher paper or large drawing sheets. If results on any paper are unsuitable, discard them; we all learn by experimentation, and no single paper is "best" in the classroom.

3

Most papers have a sizing on them or a smooth finish applied by the machines. The surface can be made more suitable for painting by sponging it off first, then painting on it, either while wet or after letting it dry. But the key to getting the right paper is to try many of them. Allow students to try several that are around and let each young artist select the one that best suits his work. Selection of paper is part of the painting process and students should become conscious of the varying surfaces, weights and qualities of the grounds on which they work. It is also valuable to talk of the paper by name or type. It is better to refer to the "140 lb. cold-pressed paper" rather than "the white paper with little bumps," or "oatmeal paper" rather than "brownish paper with the funny surface".

1 *Heavy (80 lb.) drawing paper absorbs well, has some resistance to wrinkling, especially if worked in drier methods. Stylized faces make use of several techniques and large white spaces. On drawing paper, 18 x 24. Reseda High School, California.*
2 *Texture of student grade watercolor paper can easily be seen in this 12 x 9 study by the author. Painting is watercolor wash, ink wash and stick and ink lines, done from observation.*
3 *If the paper is to be handled roughly, other papers or boards might be used. Tagboard was employed in this experiment, because PVA glue, watercolor, ink, spattered color and scrubbing were all used on the surface. Work is 24 x 30. Paul Revere Junior High School, Los Angeles.*
4 *Oatmeal paper absorbs washes well but wrinkles in the process. Some student papers don't wrinkle as much but have much harder surfaces. Try several and choose. On oatmeal paper, 24 x 18. Lutheran High School, Los Angeles.*

4

1 Army mess tray, available at surplus stores, is nearly perfect mixing tray, having several different sized spaces and stainless surface. Tray can be sprayed with white enamel for better idea of the actual hues being mixed.
2 Painting surface (here a 24 x 24 piece of 1/4 inch Masonite) should be tiltable to any angle. Books, purses or other props can maintain a steady slant.
3 Mixing trays come in all sorts of molded plastic shapes, but some artists like the porcelain covered butcher's trays best of all. Even plastic-surfaced paper plates (divided and disposable) are satisfactory.

1

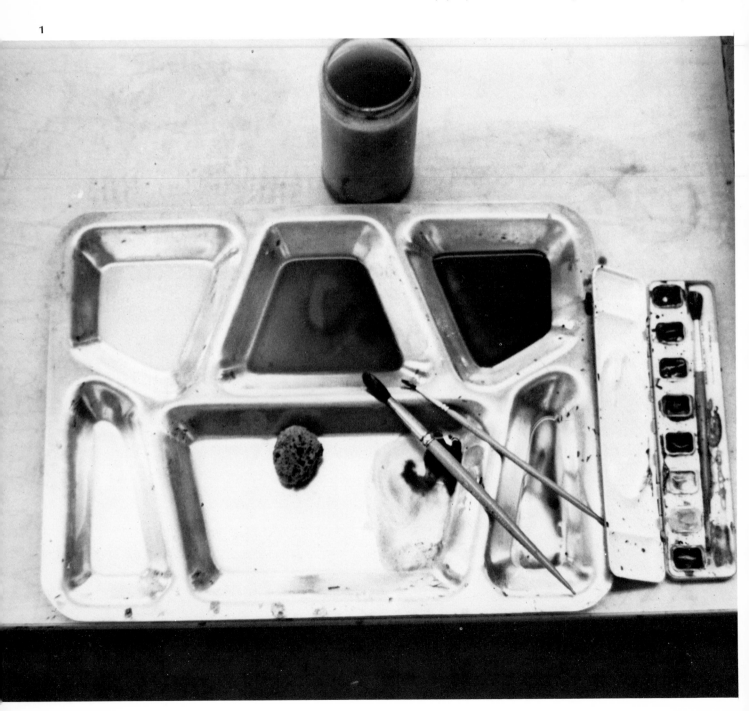

Mixing Trays, Water Containers and Working Surfaces

At last, an important item which doesn't involve high costs at any level. Watercolor from the pans must be mixed with water and then applied to the paper. We're now concerned with where this mixing takes place.

Mixing trays or watercolor palettes come in all sizes, shapes and materials — from small round plastic ones to large enameled metal ones. Boxes of watercolors come equipped with lids that convert to mixing areas when opened. These are usually too small for large washes and often provide a limited number of mixing spaces.

Ingenuity can provide mixing trays from any number of sources, since the major requirement is some sort of separated flat spaces in which color and water can be mixed. Discarded TV dinner trays are excellent, as are old Army mess trays. Metal trays may be sprayed with white enamel to give a true white background on which to mix colors, but it is not essential.

Some artists use the enamel drip trays from old gas ranges or sheets of white glass for palettes, because they provide extremely large mixing areas. Porcelain-enameled butchers' trays are also popular. Others prefer the white plastic trays produced by many art supply companies. But anything that will provide mixing areas large enough is satisfactory. Try using disposable paper plates that have divided sections and plastic coatings.

Plenty of water is essential for mixing colors and cleaning out brushes. Large jars, cans or plastic containers work well — the larger the better. The water in small jars gets dirty so fast that students are constantly on the run for replacements.

The surface on which the paper is laid should be firm enough to stand some pressure. It should be as large as or larger than the paper and must be able to be slanted. The angle of slant should be flexible, like placing a drawing board on one or two books, or on a table easel. The degree of slant varies with type of work — wet or dry — or is simply governed by the young artist's personal preference. Horizontal surfaces will produce "wells" or "pools" of color that are often objectionable, and the slanted board should help eliminate this problem.

Masonite or plywood panels make excellent painting surfaces, as do the traditional softwood drawing boards. If the painting sheet is to remain wet for extended working periods, the painting surface should be non-absorbent, like a sheet of glass or formica surfaced board.

2

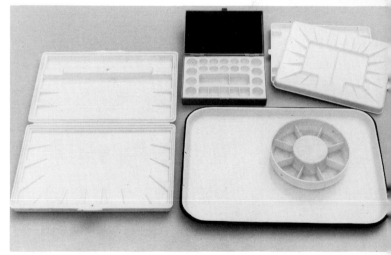

3

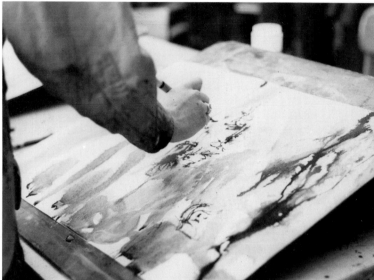

Other Tools, Materials and Surfaces

In a day of experimentation and enchantment with unique effects, watercolor is not to be excluded. Although mostly thought of as a traditional medium, it has qualities that enable ingenious students to work with any number of experimental approaches. Here are a few items that might be tried for special effects:

toothbrush: spatter; stiff brush; dry brush techniques
cardboard: scrape wet areas; dip in color and "print"
sponge: make stampings; lighten dark areas; sponge out shapes
facial tissue: scraping wet surfaces; dabbing wet areas for stippled effect
pencils: sketching; roughing in big shapes; shading
ball point pens: sketching in shapes; drawing details; fine lines
blotting paper: soaking up unwanted water on color
razor blades: scratching out white areas, lines; texturing surface
palette knives: surface interest in wet areas
pen and ink: detail; texture; part of drawing technique
felt tipped watercolor pens: complete paintings; touching up areas in aquarelle; color lines or textures
salt: sprinkled in very wet areas and allowed to dry untouched — produces star-like or snow-flake effects
wood scraps: can be painted and stamped on paper
crayon: resist techniques; color accents
inks: colored inks for accent and transparency
gesso: interesting surfaces; overpainting opaque white areas
brayers: squishing color around on wet surfaces
masking tape: to shield areas when painting or sponging out
rubber cement: as resist and blocking out medium

Some artists feel that a pure aquarelle painting is the only thing for them, while others take advantage of many excitingly different surfaces or tools that can help them communicate their ideas and feelings. Neither approach is absolutely correct for everyone. Each artist must feel that the experimental materials are bettering his ability to get his message across — or else they are merely gimmicks.

1

1 *Blue watercolor washes provide the atmosphere for a very sensitive pen, stick and ink drawing, done from a student model. Work shows excellent perception and is done on large drawing paper, 34 x 22. Hollywood High School, California.*
2 *Two colors of fiber tipped watercolor pens are used in this op art painting which employs the displacement method of designing. Concentric circles and vertical lines provide the spaces to color. On drawing paper, 10 x 10. Lutheran High School, Los Angeles.*
3 *Other tools that a watercolorist might find useful include knives, razor blades, pins, scissors, screwdriver, reed pen, compass point, etc. These tools can scratch, scrape, scar, rip, tear, cut, or otherwise abuse the surface of the paper before, during or after it has been painted.*
4 *Gessoed illustration board (24 x 30) provides a textured surface for this watercolor painting. A new surface often increases interest in working with a familiar medium. Gardena High School, California.*

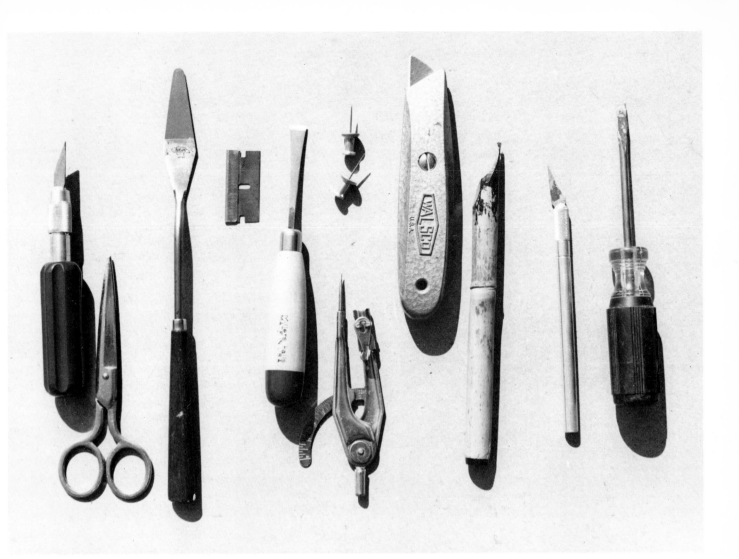

3

2

4

HOW THE PARTS of the painting are arranged on the paper is called design or composition. And how the painting is put together is really a matter of personal taste — the personal desire of the artist. But there are certain elements which, if put together correctly, will produce a pleasing design. What the artist has to work with are called the elements of art or design; ways to put them together are called the principles of design. Helping the students become aware of these tools of the artist is a full-time job in the art room, but the more aware the students become, the more knowledgeable and sophisticated are their tastes.

The elements of design include (the list is different with almost every teacher and every book) line, color, shape, value, texture, space and form. The principles of design include (this list varies even more) balance, rhythm, emphasis, unity, variety, proportion and movement. These principles are concerned with how the art elements relate to each other — line to line, shape to line, and so on. What we are really concerned about is this relationship of parts. These parts must work together and be satisfying — then the design will be good.

Design can be taught formally in a design class or incidentally in drawing and painting classes And this is probably where it is most easily understood by students — right during the painting process. Lack of space prevents a complete analysis of watercolor paintings according to all the elements and all the principles of design. But a few of each that have special bearing on watercolor painting will be discussed.

Awareness of design can be achieved with a few critical assignments (selected from what follows) and with some well-chosen words spoken at the right moment, as students are working on paintings. Students' taste will never be improved if they aren't encouraged to be aware of what good design is. And this prodding and pulling is a constant thing, not relegated to design classes alone, but to all art classes in the school.

2

3 DESIGN AND COMPOSITION

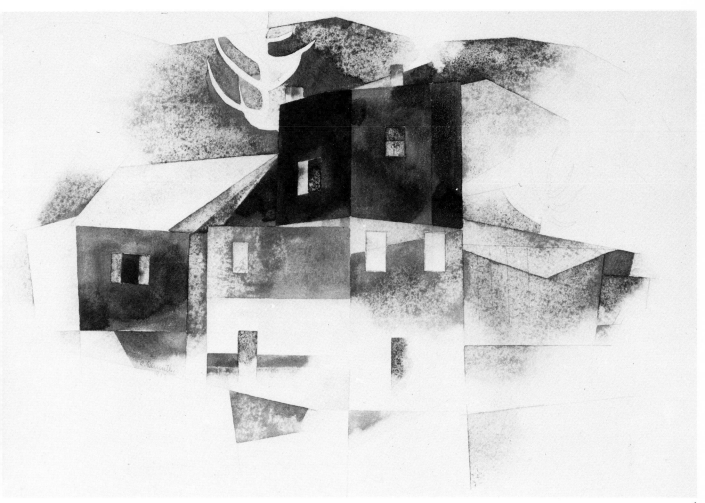

1 Old Houses. *Charles Demuth, watercolor, 9¹/₂ x 13¹/₂. Building and landscape shapes are reduced to simplest terms and arranged at the artist's discretion. Contour lines continue past the shapes in a cubist design technique. Courtesy, Los Angeles County Museum of Art. Collection of Mr. and Mrs. William Preston Harrison.*
2 *Everyday subject matter can be simplified and handled in a unique way for dramatic design. Watercolor and ink painting is 24 x 18. Gardena High School, California.*
3 *Design elements are often handled more easily when color is eliminated. Here, Robert E. Wood sketches with brush and ink, producing simplified shapes and dark and white patterns. He cuts dark areas around lights to produce white shapes. No lines were drawn first to delineate shapes.*
4 *Select only a part of the total subject and treat it with your personal design and painting technique. Designing often involves changing the appearance and/or arrangement of the parts of the object or scene. 22 x 30 watercolor. Reseda High School, California.*

1 Rock Fishing. *Phil Dike, watercolor and ink, 22 x 30. When an artist has worked with his subject matter for many years, he can arrange and rearrange the parts at will. Phil Dike is an absolute master of the sea and its shore, and designs the elements to fit his needs at that time. Courtesy of the artist.*

2 Pattern is a direct and simple way to work with the elements of design. This mixed media (PVA glue, watercolor and ink) design makes use of line, value, texture, color, rhythm, repetition, emphasis, variety, unity and balance. Work is 10 x 16. Paul Revere Junior High School, Los Angeles.

3 The interest in a painting can be shifted forward or back by the placement of light and dark areas. The four demonstrations (each 8 x 10) by Robert E. Wood show light against dark sky; dark buildings against a light sky; emphasis on foreground buildings; light foreground and light sky. All are done rapidly in three values and the white of the paper.

4 Mexican Dance. *Francis de Erdely, watercolor, tempera and ink, 28 x 22. Being a master draftsman, the artist incorporates his unique design technique and skill with line into his watercolors. Courtesy, Los Angeles County Musem of Art, California National Water Color Society Collection.*

5 Take a single item, like this unicycle, and repeat it several times from several angles. Vary the sizes and overlap the parts. This fascinating 18 x 24 design is in watercolor. Reseda High School, California.

Some Things to Do

Concern with the relationship of the parts of a painting produces harmony, a feeling that it all goes together. In order to achieve this coherent feeling, several things can be done:

Provide a *way into the painting* and movement around in it.
Divide the space in an interesting way.
Provide the *center of interest* (and several less important ones).
Provide a *variety* of shapes, sizes, colors, lines, etc.

The *entrance to the painting* is usually at the bottom. The eye goes over the foreground objects and into the main part of the painting, travels around from object to object, rests at the center of interest, and exits in the distance, out the side, through a door or around the back of a vase. Don't put a barricade across the bottom of the painting (like a fence without a gate), but allow some way for the eye to enter.

Division of space is usually a geometric proposition and is done to organize the work. Design books will show you dozens of ways to do it — with circular divisions, triangular, serpentine, bridging, enclosing, radiation or rectangular space organization. All will work, and will depend on the subject and format. Keep divisions full of variety, making them asymmetrical for stronger visual excitement

The *center of interest* is usually the most important item in the painting, what the painting is about. It should be placed correctly, causing the rest of the painting to lead your eyes to it. It is the point of emphasis in the work, the place where the eye should come to rest. Don't put it in the center of the painting, nor near the outside edges. Definitely stay away from the corners.

Variety causes the composition to be alive, to help from being monotonous All the art elements can be brought to bear in this case — color, shape and line. A brightly colored painting can be given variety by pulling a dulling wash over a part of the work. A low-keyed painting can get a spot of bright color. A horizontal painting needs at least one vertical; buildings should be different sizes; values and shapes should vary. Pull objects forward or push them back in space. Don't allow any part of the painting to become dull because of a lack of variety in size, color, shape or feeling — unless, of course, you do it to achieve a certain effect, like boredom.

4

5

31

Some Design Concepts

Trying to arrange the component parts of a painting leads to several compositional concepts. These are overall working plans for putting the painting together. Depending on the subject and the treatment, paintings can be static or dynamic, quiet or in movement. Static paintings are oriented in vertical and horizontal blocks, often contain straight lines, and are usually quite organized. Dynamic paintings seem to lean with the action; they flow, bend and rush. They make use of curved lines and organic shapes rather than straight lines and geometric patterns.

Another concept involves the change in the painting from structure to finished work. You can work from abstract shapes into nature or you can start with nature and work into abstract. Both ways require the basic tools of design principles. Begin by putting down large geometric or organic shapes in an interlocking pattern, and when dry, begin to develop the shapes into recognizable objects. Or start by putting down house, fence, trees and sky, and by simplification, overlapping washes and value contrasts, develop more abstract patterns that hold the painting together. Both processes can end up with nearly the same result.

In order to show the irresistible surge of eye movement to a hill top, put the horizon line close to the top of the sheet. Such high horizon compositions tend to add dynamic excitement and instability to the subject. Low horizon paintings force emphasis on the sky, clouds or space.

Bridges can be built across the page from left to right, with vertical protrusions reaching up and down to the margins. The crossing point usually contains the center of interest and should therefore not be in the center of the page. Keep both the bridge itself and the extensions off-center. This concept usually includes large portions of white space in several of the corner areas, this white space being part of the design. Contact the margins at least two times to keep the subject from floating away. The bridge might be only partially completed, allowing the void or blank space to carry the weight of the completed shape. Such voids can be very strong, even though nothing is painted there.

Most artists invent new concepts and change these compositional frameworks from time to time in their development. These underlying structures determine the final shape of the painting, but might not show when it is finished. Then again, some artists like to leave this framework evident.

3

4

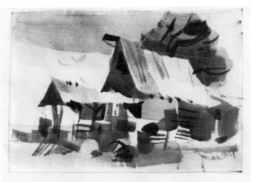

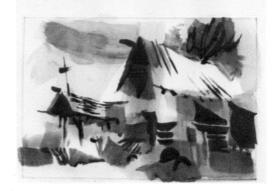

1 *Abstract shapes form the structure for paintings. These three demonstrations by Robert E. Wood show a static and blocky arrangement; a slow movement with soft curves; and a fast movement with sharp diagonals. Natural elements can now be fitted into these shapes.*
2 *A sheet of studies by Robert E. Wood reveals the artist's thinking process when arranging the abstract pattern of his paintings. Shapes might become islands, clouds, trees, buildings, rocks or whatever the artist is working on.*
3 *Cannery Row, 1971. Gerald F. Brommer, watercolor and collage, 22 x 30. Large pile of rocks leads the eye into the distance, which here has a high horizon. Such design forces the viewer to look into the painting and over the foreground. The white of the paper is part of the design. Collection of Mr. and Mrs. William Wise.*
4 *A bridge from left to right, with extensions to top and bottom margins, allow this student to link signs, buildings and windows into an interesting design. Watercolor, 24 x 14. Lutheran High School, Los Angeles.*
5 *Robert E. Wood shows two approaches to design: top sketch is worked from observed shapes which were simplified and made into abstract pattern. Bottom sketch is brushed down first in abstract shapes (see other three shape designs) which are then textured, patterned, or contrasted to produce recognizable forms.*

1 The type of brush, paper and colors will help determine the brush stroke and therefore a part of the style of the classroom artist. Boldly brushed shapes and good value contrast characterize this 24 x 18 watercolor done on student watercolor paper. Reseda High School, California.

2 New Mexico, near Taos. John Marin, watercolor, 11½ x 16. This great artist was a prime force in aquarelle painting in America. His style involves a vignetted subject (not reaching the margin at any place) with dynamic action inside the frame. Notice the simplification of natural elements in the foreground and the strong treatment of the sky. Courtesy, Los Angeles County Museum of Art, Mira Hershey Memorial Collection.

3 Governor's Mansion. Helen Luitjens, watercolor, 30 x 22. Fluid washes and a vibration set up in colors, characterize the artist's style. Large sections of white paper force the viewer to get involved and complete the work visually, while other areas are finished boldly and simply. Courtesy of the artist.

4 A selective eye picks out part of a total building to record. Detail is kept to a minimum but essential parts are carefully textured and worked. The student begins to develop his style. Every lesson alters the process a bit. Watercolor on 18 x 24 drawing paper. Lutheran High School, Los Angeles.

1

2

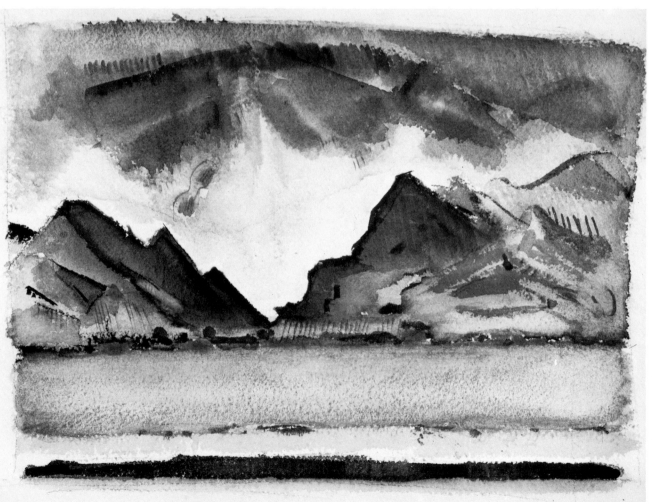

The Search for a Personal Style

Developing our own way of seeing and painting is a process that starts early in life. Everything we see and record influences our style; the books we read, the movies we see, the paintings we study, the teachers we listen to, all have a bearing on how we work.

We can't exist in a vacuum, so our style of work will change as we develop a painting vocabulary. We try this and experiment with that. We switch media. We look and draw; we discuss and paint. And our way of painting — what we want to say and how we say it — changes, as we do.

Changing is not bad, because it shows a growth and awareness of new concepts, resulting in different "periods" in the life of the artist. Jean Dubuffet, a restlessly prolific French artist, claims to have gone through more than twenty-three recognizable periods. And he didn't stop there, but kept experimenting and searching for yet another stylistic period.

In students, the search is constant. Not many have a mature and terminal method of working that can't stand change. So, challenge them. Give them new assignments. Encourage them to stretch their seeing and recording abilities. The outcome of this challenging and exciting growth process will be a major step in the development of the young artist's style. Every confrontation with a new teacher, a new work of art, a new visual experience, will temper that style.

Personal characteristics will emerge in students' work at early ages. And the personal touch shouldn't be discouraged, but it should be stretched, added to and expanded to make room for new concepts and ideas. In the search for style, the teacher is merely a catalyst, not a dictator; you help styles develop, not force them into channels. Provide experiences and assignments, field trips and lectures, books and prints, and your personal encouragement. Watching styles grow and flower is one of the particular joys of the art teacher.

4

2

1

The Liquid Line

Although line is principally a drawing technique, the water-colorist can manipulate his brush to produce some fascinating lines. It is true that watercolor makes extensive use of flat washes, fat brush strokes and value contrasts, but line still holds an important place with many painters. Others won't tolerate it.

Line can be used to outline shapes in a wash painting. It can also be the concept that an artist employs to articulate his ideas. It can be drawn with pen or stick and ink and left as part of the painting. Line can unite as well as divide parts of the composition.

Using a large or small brush, the artist can trail thin lines, thick lines, weighted lines, drybrushed lines or liquid lines. Artists have found ways to incorporate line in their watercolors to strengthen compositions or lead the eye from place to place. Lines might be ropes, tree branches, birds in flight, running water, shadows, window sills, drain pipes or eyelids. Massed together they can produce textures.

Oriental sumi-e painting and calligraphy make use of line exclusively and beautifully, better than any other style in the world. From that complete use to a subtle shading in a wash painting, line runs the gamut of uses and expression.

One thing is important, however. When line is used in water-color, it must become part of the painting — feel that it belongs. It must share in the unity and completeness of the work. If it looks like something added over the painting, like something foreign to the work, it is detrimental to the painting. If the painting has a very transparent feeling, the line must also be transparent. If the painting is strong in value contrasts, the line can also be more bold. But it must belong, or leave it out.

1 *The use of line can produce action and dynamic contrast. Remove the lines from this boatyard and the painting will fall apart. Watercolor and ink, 18 x 24. Lutheran High School, Los Angeles.*
2 *Newsboy. Tyrus Wong, watercolor, 24 x 14. Expressive calligraphic outline shows Oriental background and training. Courtesy of the artist.*
3 *Spotlights of Las Vegas. Jo Rebert, watercolor, 39 x 27. Not only is the tondo composition effective, but the artist's handling of concentric lines produces color vibrations and action. Courtesy of the artist.*
4 *A channel print (slosh watercolor on paper, fold over and press) has its shapes outlined with several sizes of pens and inks, 12 x 14. Paul Revere Junior High School, Los Angeles.*
5 *Delicate contour drawing is shaded selectively with watercolor for a fascinating effect. 24 x 18 on drawing paper. John Marshall High School, Los Angeles.*

3

4

5

1

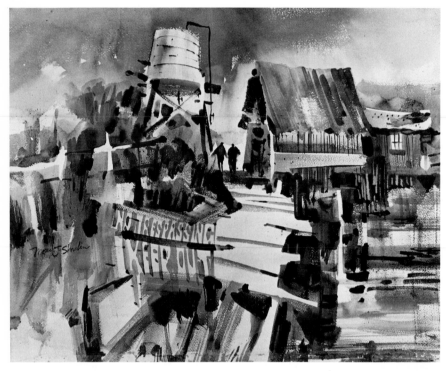

2

3

1 No Trespassing. *Morris Shubin, watercolor, 22 x 30. Excellent value contrasts (dark against light; light against dark) make a strong composition. Squint your eyes and notice that the shapes remain the same — they don't disappear. Rough paper emphasizes the dry-brush technique in some places. Courtesy of the artist.*

2 *This middle value painting (neither too light nor too dark) is done from a student model, and uses crayon and watercolor washes on large (32 x 24) drawing paper. Hollywood High School, California.*

3 *Dusk and night provide ideal subject moods for low-keyed (dark value) paintings. This 24 x 18 work is on student grade watercolor paper. Lutheran High School, Los Angeles.*

4 *A sheet of value studies by Robert E. Wood demonstrates the effective changes that values can make in a painting. Courtesy of the artist.*

5 Southwest Mission. *Robert E. Wood, watercolor, 15 x 22. The bright light of the Southwestern desert is felt because the artist uses high-keyed colors (light values) for his work. Notice the excellent use of washes in the painting. Courtesy of the artist.*

Value: The Dark and Light of It

If you look at the natural landscape, you will see hundreds of values of dark and light. You can't possibly paint them all, so don't try. Instead, simplify the values and your painting will have a better chance of succeeding. You can simplify the values you see simply by squinting your eyes, causing you to see only large blocks of dark and light. Some artists look through a piece of blue glass, but the result is the same — simplification of pattern and elimination of detail.

Basically, if you can break down what you see (figure, still life or landscape) into three values, you have the problem solved. The midde value is the local color (no shadow or light) while highlights and shadows form the extremes. A painting with full chiaroscuro (complete range of values) should go from nearly black to almost pure white.

This three value system, used by many professional artists, makes use of the white paper as the lightest value. In opaque painting (oils, tempera, opaque acrylics, etc.) the lights can be added last with white paint. In watercolor, the whites must be planned in advance and left alone. High-keyed paintings make use of light values (lots of water to little pigment); low-keyed paintings, of dark values. Most paintings will make wide use of the middle values with dark and light accents.

Generally, watercolorists start by putting down light values and work through middle values to darkest, simply because working over previous areas makes them darker. You can lighten some areas, but usually only for accents. Where the lightest light and darkest dark come together, is the point of greatest contrast; thus, a center of interest. Therefore, keep extreme value contrasts away from the edge of the sheet.

As you work on your painting, squint your eyes occasionally to check out the value reading. If it all turns gray or runs together, you have to increase the contrasts. Work dark against light and light against dark. If the contrasts are not present in the still life, you might have to exaggerate them in the painting.

Value contrasts are one of the major factors in the sparkling quality of watercolors. The darks make the lights shine and the lights make the darks seem deeper. Light values can be tied together in a painting and so can dark values. This can be accomplished by flowing unifying washes over certain continuous dark shapes. This keeps the parts of the painting from becoming decentralized.

39

Color: Some Notes

Selection of colors in a painting is dictated by the method of working. Color can be realistic, adhering to nature as closely as possible; or it can be subjective, with the artist using color he feels is right at that time. Between these two extremes exists a wide range of possibilities, depending on the purpose and makeup of the artist.

Books have been written on color and its application to painting. Some watercolor books contain entire chapters on color — its use, mixing, combinations and applications to specific situations. Several aspects of color have special interest to the watercolorist, and they will be touched on here. If color fascinates you dig a bit deeper into some of the books listed in chapter nine.

Watercolor dries lighter and should therefore be applied a bit more boldly than other paints. Adding this "extra" bit of intensity is called "charging" the color. Often it is done by brushing almost pure color into a wet color area of the painting, giving it a chromatic boost. Wet a few squares and flow light washes into them, and then charge with intense color. Mingle the colors but don't overwork them.

Overlay washes often result in fascinating color changes. A knowledge of the color wheel (page 41) is essential to making watercolor overlays work. Take six of your colors and make vertical washes of each, as wide as your largest brush will make, about ten inches long. When completely dry, use the same six colors and make horizontal washes overlay the vertical washes. Leave a quarter inch of space between the washes, so they don't bleed together. Don't scrub or brush back in the process — just one stroke washes. Be sure to clean the brush between each application. When dry, notice the quality of color when one wash is put over another. Notice the effect of cool over warm and warm over cool colors. Use this information in your painting, because this **characteristic** is peculiar to watercolor and gives the finished painting its depth and vibrancy.

A color can be grayed, if it is too intense, by putting a complementary color over it, or by mixing the two in the palette. Don't use black to tone down intensity. Many artists never use black in their palette, preferring to make darker colors by mixing. Other artists use it all the time. Black, in student colors, often has an opaque look and tends to seem foreign to the rest of the colors.

Most inexpensive colors are rather uninteresting in themselves, and need to be mixed to get satisfying results. This knowledge only comes from practice and experimentation with your set of colors.

Color assignment can involve writing a poem about a color and boldly illustrating it. This orange study is 12 x 18 in size and done in watercolor and tissue paper collage on wrinkled drawing paper.
John Marshall High School, Los Angeles

Muddy colors result from overwork (too many washes), from scrubbing (using the brush too much) or from using the more opaque colors. Such areas can be helped or saved by lifting some shape or line out of the area with a sponge, stiff brush or sandpaper. This lets the dulled area breathe again and brings it to life. Sometimes an opaque line or pattern, laid over the area, can spark it to life. Try several things before discarding the painting.

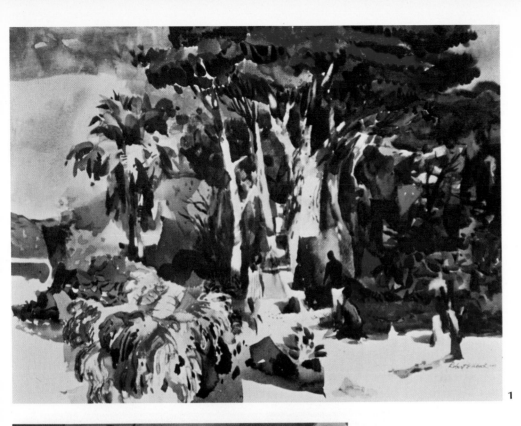

1

INTENSE COLOR

1 Flame at the Top. *Robert E. Wood, watercolor, 22 x 30. Watercolors can be as intense as any other medium, if handled correctly. As bright and vivid as the colors are, no muddiness has occurred. Strong value contrasts and excellent design typify this work. Courtesy of the artist.*

2 Gelati, San Marco. *Miles Batt, watercolor, 30 x 22. If you want to see how the artist has simplified his subject and used his colors in a personal way, find a photograph of St. Mark's Basilica in Venice, together with surrounding buildings and sculpture. This painting is the essence of simplification and personal style. Courtesy of the artist. Collection of Susan Korzenewski.*

3 Sunset Glow. *Jo Liefeld Rebert, watercolor, 22 x 30. The artist has simplified her shapes through many steps, until these carefully designed areas remain. Intense colors produce a vibrating surface. Courtesy of the artist.*

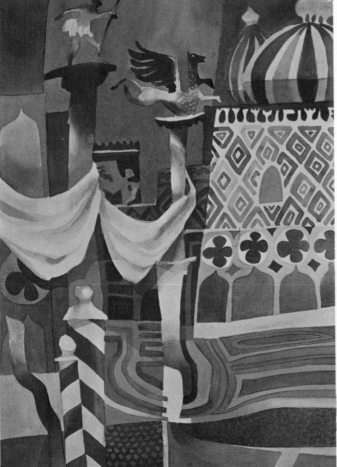

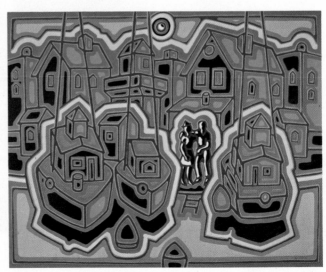

2 3

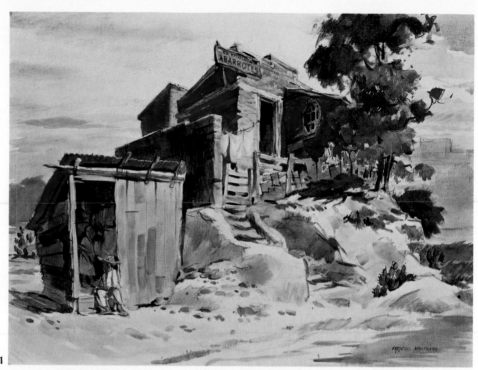

1

2

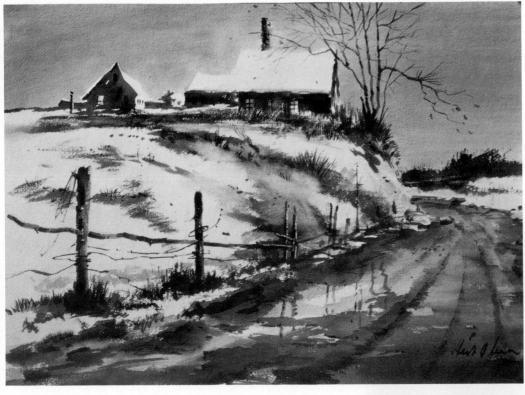

3

4

MUTED COLORS

1 Market on a Mound. *Frederic Whitaker, watercolor, 22 x 30. Although painted in intense sunlight, the artist has grayed his colors (using complementaries) to show the patina of age and dust. Even the green of the tree is grayed with a bit of red. Courtesy of the artist.*

2 Bend in the River. *Roland Golden, watercolor, 22 x 30. Careful composition and a sensitive treatment of textures are evident in this work. Though it is autumn and the sun is shining, the artist chose to gray his colors (except for the center of interest) to create a particular mood. Notice the careful brush strokes in dashes, dots and lines. Courtesy of the artist.*

3 Winter. *Herb Olsen, watercolor, 22 x 30. Muted colors set the mood for a gray winter day. The artist used a limited palette (only a few colors) and mixed them to produce almost a monochromatic feeling. Earth colors were used and no bright accents are seen — you can almost feel the cold. The snow is the white of the paper. Courtesy of the artist.*

4 Calle del Real de San Agustin, Taxco, Mexico. *Miles Batt, watercolor, 30 x 22. Beautifully simplified and stylized, the buildings of Taxco have been painted with toned-down color to project a mood. Look carefully at the transparent overlay washes and at the running paint, which is a sign of the struggle between the artist and his work. Lighter buildings stand forward from a darker sky (which isn't even blue). Courtesy of the artist. Collection, M. Tannenbaum.*

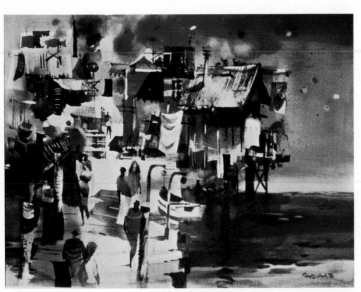

1

LIMITED PALETTE

1 On a Red Day. *Robert E. Wood, watercolor, 22 x 30. The artist has painted wharf spaces, such as this, many times, so the design is in absolute control. Here he uses a limited palette of reds, oranges and blues, but he often uses a full palette for the same subject. Nearly every transparent watercolor technique is employed in this work. Courtesy of the artist.*

2 Beginning of Fall. *Roger Armstrong, watercolor. Bright display of color, but the palette is limited to ochres, oranges and browns. The painting is an excellent example of wet-in-wet with a few crisp accents to emphasize tree textures. Courtesy of the artist.*

3 Along Martin's Ridge. *Win Jones, watercolor. A drybrush glaze build-up, typical of the artist's detailed and linear approach to watercolor (see chapter 8). Few colors are used, but they are sufficient to create the desired mood. Courtesy of the artist.*

4 Fog at Jacksonport. *Phil Austin, watercolor, 21 x 29. A limited palette of earth colors creates the dull and foggy impression. Brighter colors and a greater variety of hues would destroy the feeling. Christopherson Collection.*

5 *Shells, sand dollars and starfish form the patterns for this excellent design, carried out in bright but limited colors. Crayons were applied first, then tempera washed over. Designs were scratched through the tempera, then watercolor and ink were brushed on the surface. Work is 24 x 18 on tagboard. Paul Revere Junior High School, Los Angeles.*

2

3

5

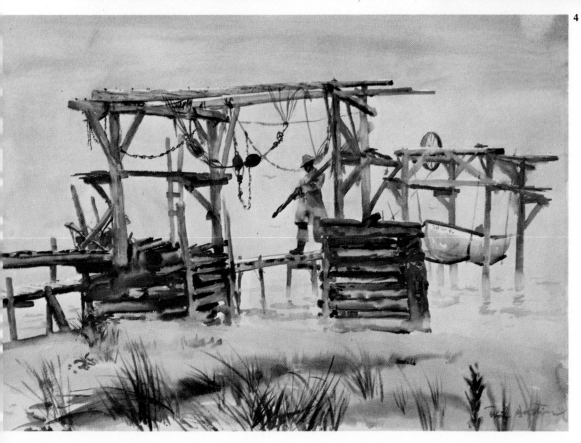

4

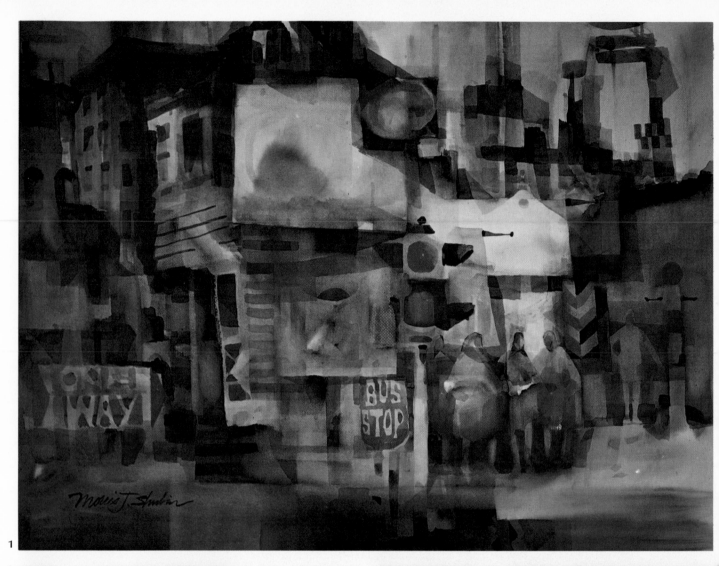

1

2

3

CONTRASTING COLORS AND VALUES

1 Bus Stop. *Morris Shubin, watercolor on mounted board, 30 x 40. Preliminary abstract shapes were washed in, and the resulting shapes determined the content. Areas were lifted and scrubbed out while darker values were produced with more washes. Excellent control of this technique produces rich surfaces and strong contrasts. Courtesy of the artist.*

2 *A full range of colors, combined with contrasting values (squint your eyes to see them), produces a strong painting. This work is part of a much larger still life, and colors are the personal selection of the artist, not the actual local hues. Work is 18 x 24 and takes advantage of the runs and puddles which occur on drawing paper. John Marshall High School, Los Angeles.*

3 Old Mosque — Samarkand. *Millard Sheets, acrylic watercolor, 22 x 30. The artist uses acrylic paint in his typical transparent style because of the brilliance of the hues. These colors and their contrasts are characteristic of the geographic location portrayed. Note the pointillist effect in many places. Courtesy of the artist and Dalzell Hatfield Galleries.*

4 Courage thru Armor. *Al Porter, watercolor, 22 x 30. Dramatic contrasts, in both color and value, produce a strength that usually is not associated with watercolor. This work is an excellent demonstration of all aspects of the principles of design. Courtesy of the artist.*

5 Storm over Venice. *Gerald F. Brommer, watercolor, 22 x 30. A full range of colors is employed, but value contrasts are just as important. Shadow colors (blue tones) are pulled over several areas to unite them and prevent a chaos of little pieces. Dark sky is strong foil for lighter buildings. Collection of Home Savings and Loan Association.*

4

5

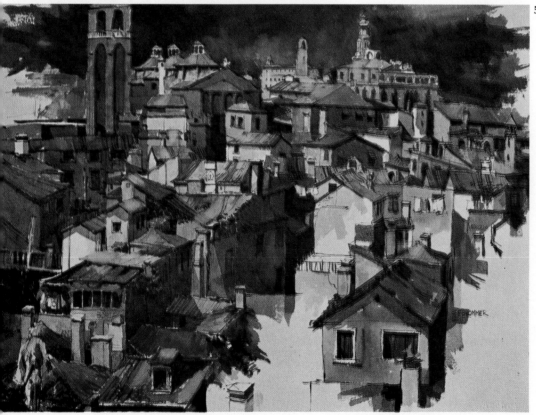

2

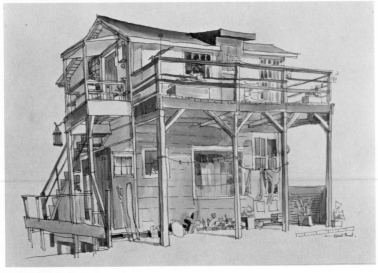

1

HIGH-KEY AND LOW-KEY COLORS

1 *Student artist went to a Titian painting for his idea but changed the style to his own liking. More importantly, he changed Titian's deep colors to a high-keyed palette, creating a completely different feeling. Watercolor is 24 x 18 on drawing paper. Reseda High School, California.*
2 *Old Codfish House. Hubert Buel, watercolor and ink, 15 x 22. Sketch was done on location with India ink, and a few high-keyed washes were added later for color suggestion and weight. Courtesy of the artist.*
3 *Decomposing Granite. Lee Weiss, watercolor, 26 x 40. The artist has developed a fascinating technique (see chapter 8) for looking at nature close-up. Her colors are dictated by the subject and the values are low-keyed, also to suit the subject. Collection of Dr. H. Lester Cooke.*

3

COLOR WHEEL

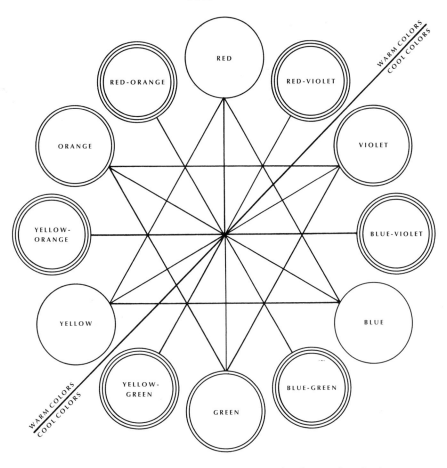

COMPLEMENTARY COLORS are opposite each other on the wheel

PRIMARY COLOR

SECONDARY COLOR
made by mixing two primaries

INTERMEDIATE COLOR
made by mixing neighboring primary and secondary colors

Other quick notes on color before going on:

Skies don't always have to be blue.

A small intense color can balance a large muted one.

Local color refers to the actual color of a thing, without highlights or shadows.

Adjacent colors have effect on each other (experiment).

The values of color (see pages 38-39) are more important than the color itself in making the painting work.

Mood color or super color is the overall color feeling of the painting.

Warm colors seem to advance; cool colors recede.

A limited palette (only three or four colors) helps eliminate many color mistakes in a painting, and makes the artists work with the values more carefully.

You learn how color works only by painting, and then remembering what you did to get certain effects.

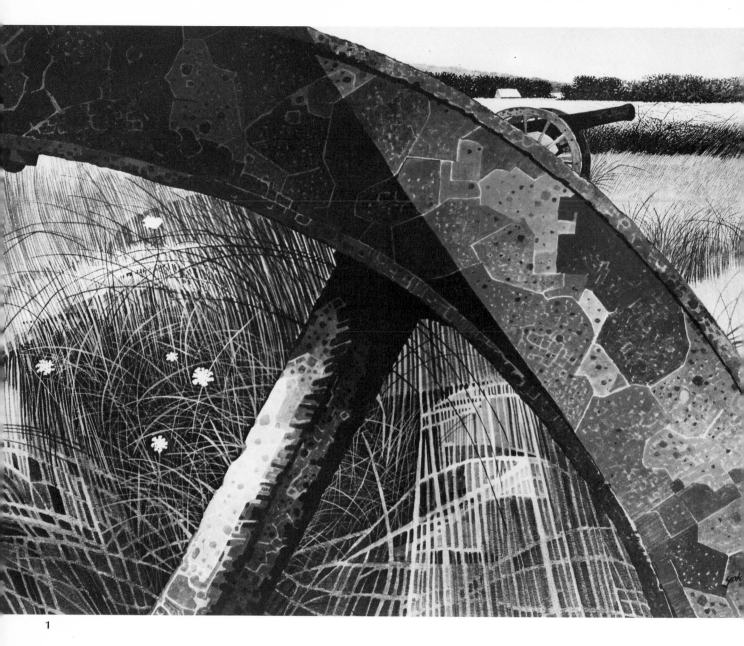

1

1 Nature Heals. *Roland Golden, watercolor and some opaque white, 22 x 30. Foreground and background are both treated with careful detail, but the viewer's eye is forced over the rusting wheel (only partially shown) to rest on the cannon in the middle ground. Notice how it contrasts in value with its surroundings. Courtesy of the artist.*
2 *Clowns stand out in a crowd of regular people, so this red-haired fellow becomes the center of interest. He is brighter than his neighbor clown, and takes over the interest from him. Watercolor and ink, 12 x 18. Paul Revere Junior High School.*
3 *Areas of greatest contrast draw attention to themselves. Here an oasis and water tower capture the interest. Watercolor on drawing paper, 24 x 18. Lutheran High School, Los Angeles.*
4 *Centers of interest can be centralized or de-centralized, as Robert E. Wood demonstrates.*

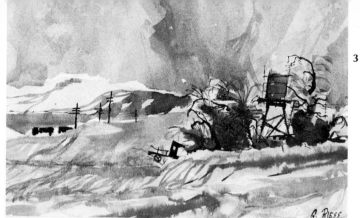

Emphasis: The Center of Interest

Probably no painter ever guided the viewer's eye around in his work better than Rembrandt. You are absolutely compelled to go where he wants you to go. All paintings should attempt to do the same thing — guide the viewer to the key part of the work. And that point is the center of interest, the point of emphasis.

This important place (a person, tree, apple, eye, light or whatever else) can be emphasized in several ways. It can be the area of greatest contrast in values (see pages 38-39) or the place of most intense color. It can be the flower among leaves or the boat in a quiet lake.

The center of interest can also be stressed by simply making it different — a texture against something smooth, a clown in a crowd, a house in the landscape, a cactus in the desert. Our eyes are drawn to the different and distinctive item.

Eyes can also be led into the bottom of the painting, moved over foreground objects and brought to rest on some distant item — house, tree, hill or sun. Movement to the center of interest can be directed by trees, fenceposts, brush strokes, lines and progressions of colors or values. Looking at the many paintings in this book, it is easy to find the centers of interest in most of them, but it is more fun to see how the artist helped you find it.

Most paintings have a single point of greatest emphasis with several points that share equal billing. If you are trying to stress the unity in a landscape (how it all goes together), you might not want to have a single point of interest. Paintings don't have to have a center of interest, but most of them do. It's one way to unify the painting and give purpose to its design.

CENTRALIZED

DE-CENTRALIZED

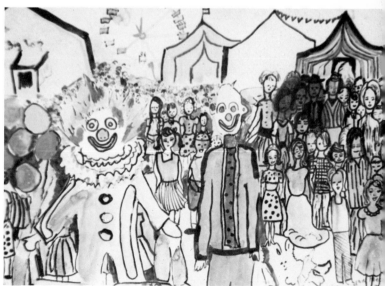

Movement and Action

Look at the paintings on these two pages. They move! All are different, yet they share one common factor, they are charged with dynamic action. They differ from still lifes or most landscape paintings, and the difference was created on purpose.

To produce a feeling of real movement in the design, several things can be done. The technique of applying the paint can show movement in quivering lines, in vibrating colors or in pulsating rhythms (see Keith Crown's work in chapter eight).

Rapid and excited stroking of the brush can create movement. A partially incompleted work stresses hurried painting (action by implication). Strong curving linear patterns with bold brush strokes cause the eye to follow the line around the paper.

Circular motion causes the eye to revolve around the subject. Slanted, diagonal and curved arrangements of shapes and lines stress imbalance and, therefore, movement. And the subjects themselves (running horses, straining athletes, streaking automobiles) can also emphasize action. Putting several of these techniques together can inject the painting with dynamic excitement.

If you want action, stay away from static arrangements (vertical-horizontal block designs). Use diagonals, vibrant color, strong contrasts, anything to get the message across. Notice again how the things on this page pulse with action, then compare them with other paintings in the book that don't have similar movement. Now give it a try.

1

2

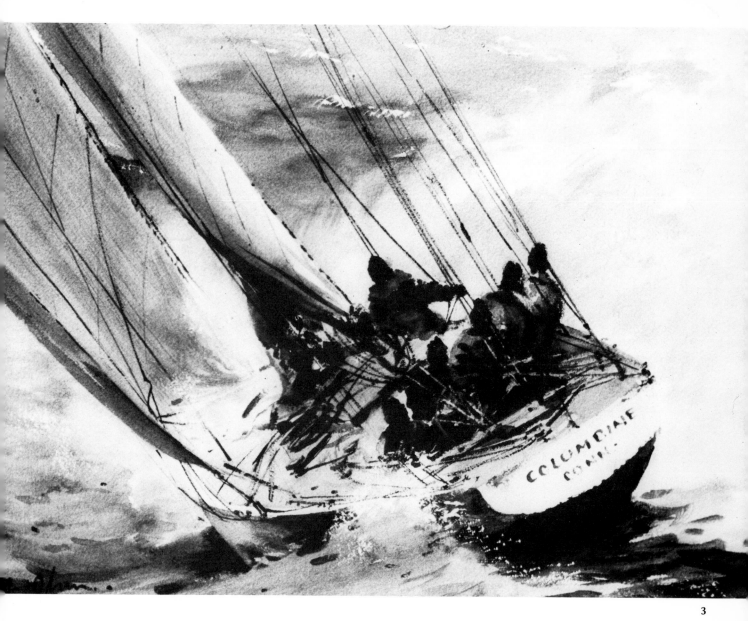

3

1 A pillow fight is certainly active, and these youngsters are swirling in circles of color and light. The rapidly stroked glazes help suggest action. 24 x 18. Lutheran High School, Los Angeles.
2 Calligraphic Rhythm. *Tyrus Wong, watercolor and ink, 14 x 24. Large sweeps of the brushes cause your eye to follow the strokes, thus moving you around in the painting, making you feel the action. Collection of Homer Clark.*
3 The Columbine. *Herb Olsen, watercolor, 22 x 30. A sailing vessel at sea is movement in itself, but Herb Olsen emphasizes action by tilting all the elements at a sharp angle. Strong value contrasts accentuate the extreme action taking place. Collection of E. C. McCormick.*

EACH ARTIST AND teacher has his own pet methods for getting students started in watercolor, which seem to work best for him. There is no single "best way" to get going. Teachers have to try several ways and go with the methods that seem to accomplish their purposes during the get-acquainted periods.

Wash Drawing as Introduction to Watercolor

Jumping directly into wet watercolor can often produce 1) fear, 2) a feeling of helplessness, or 3) a reverting to grade school practices. Several days (or longer) working with wash drawings, stressing value contrasts and wet-in-wet techniques, is often valuable in overcoming these problems. Line can be included in the process, or not, but the use of limited values of wash tends to create the correct attitude toward the transparent application of color.

Still lifes or student models make excellent subject matter for such drawings, and for later watercolors. Keep the values limited to three plus black, and work from lightest areas to darkest. Notice the effect of wet into wet areas, wet over dry, white space left untouched and contrasts obtained by overlapping washes.

Work quickly and loosely to establish a painterly quality. Explore methods of simulating textures by spattering or allowing drips to run their course. Keep painting sessions relatively free of restrictions so that exploration can take place and discoveries can be made.

Succeeding steps might involve the introduction of one or two colors, while keeping the subject matter and work methods the same. Apply color washes *over* the three-value ink wash drawings. Substitute watercolors for the washes, but work in the same manner. Keep the first palettes limited in color and stress transparency, overlapping and textural effects. Rejoice in the intrigue of happy accidents that occur in runs and puddles. Don't work initially for "finished" products, but take pleasure in the process and the exciting discoveries that invariably take place.

1

4 BASIC TECHNIQUES

1 *The freedom developed by applying monochromatic washes is essential in watercolor techniques. This juicy drawing contains runs and smudges (evidences of the work involved) and has a strong personal quality. Wash drawing, 27 x 20. Granada Hills High School, California.*
2 *Still lifes are excellent for beginning wash drawings. Emphasize value contrast, overlapping washes and flowing brush strokes; because they are all transferable to watercolor painting. 18 x 24 on oatmeal paper. Lutheran High School, Los Angeles.*
3 *A still life study in two-color watercolor washes (this in blue and red) with a stick and ink line for delineation. Wash drawing technique is easily transferred to limited palette watercolor paintings. The next step can add more color. 24 x 18 on oatmeal paper. Lutheran High School, Los Angeles.*
4 *The Holy Family. Giovanni Battista Tiepolo, brown ink and wash drawing, 12 x 8. Baroque artists used wash drawings as studies for larger works in oil or fresco. This shows line and values that would appear in a later work. Courtesy, Los Angeles County Museum of Art. Gift of Cary Grant.*

2

3

4

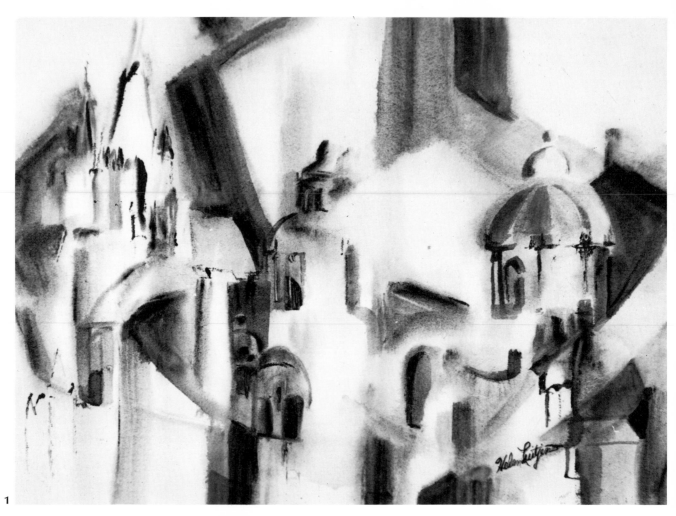

1

2

1 San Miguel de Allende. *Helen Luitjens, watercolor, 22 x 30. Juicy wet washes are restricted to certain areas while the dampened paper is untouched in other places. The artist leads your eye from one selected detail to another via these watery shapes.*
Courtesy of the artist.
2 *Explore what wet watercolor does without the hindrance of required forms. Enjoy juicy runs and bleeding washes applied to dry paper. Watercolor on 24 x 18 drawing paper. Reseda High School, California.*
3 *Let the loaded brush explore the paper. Runs, drips, puddles and bleeds are part of the process that can eventually be controlled. Painted on a dampened 24 x 18 sheet of oatmeal paper from a student model. Lutheran High School, Los Angeles.*
4 Tree Forms. *Wayne La Com, watercolor, 15 x 22. It is a great experience to soak a sheet of paper and flow colors onto it. Watch the soft blending of color into color or color into white. Disregard recognizable forms and simply enjoy the process. Courtesy of the artist.*

Using the Brushes

Everybody knows how to hold a brush. Or do they? Size, type and process are determining factors in handling the brush, but a few generalities might help. Try a variety of holds — close to the tip, at the middle or end of the handle; like a pencil or across the palm; vertically or at various angles; loosely or with great firmness. Try them all with small, medium and large brushes until a comfortable feeling is established.

Watercolor brushes (see pages 18-19) vary in size and young artists should learn at an early stage to use the largest ones first (no. 12 - 16) and continue to use them as long as possible in the painting process. Then go to a smaller size, but keep from using the tiny ones except for fine lines or accents. Large brushes should be loaded with water when they are used, since they are actually reservoirs. Juicy, sloshy and wet could describe their application of color to paper. Stroke freely at first, even standing over the work on the table, so that washes are soft and continuous.

Brushes that are wet and then squeezed nearly dry may be used like blotters to pick up excess water from the paper, or to lift out light spots in wet color areas.

Emphasis on Water (Washes)

It seems improbable that student *watercolors* are often made with very little water. But this is so. Washes should be prepared in containers that will hold plenty of water, not only thimbles full.

Painted washes are continuous areas of watercolor that take more than a single brush stroke to apply. Succeeding strokes (of either color or water) should be made at the wet edges to spread the color area. All must be done rapidly to keep the tones of the wash even. Some papers help this process while others hinder it. Color and value changes can be made while applying washes, but try not to scrub or overwork a good wash — it will just be destroyed.

Applying a loaded brush to paper is a delightful experience and should be experienced for itself. Early in the painting, large areas can be toned in and a juicy substructure can be developed. Some artists enjoy this juiciness so much that they continue to use it throughout the painting.

Look at the work on these pages. They are wet, vibrant, spontaneous and juicy in varying degrees. Some are more controlled than others, but all are done with large loaded brushes. It's a great way to get your feet wet in the medium, and to experience a sensation unique to transparent watercolor.

3

4

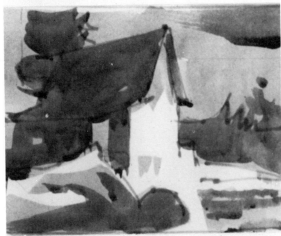

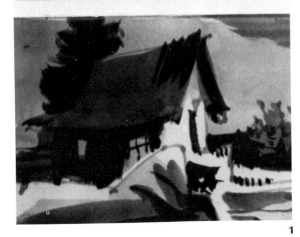

1

Ways to Start a Watercolor

Since no two artists paint exactly alike, they don't follow the same procedures in developing their work. But several steps might help get things started. Classrooms often provide still life and model material, while sketchbooks, source books and imagination can add hundreds of ideas. So the subject matter is chosen first.

Small thumbnail sketches are valuable in preparing the composition of major elements. Make a pencilled frame about two by three inches and sketch the main objects in place. Here is where arranging and rearranging should take place. Plan the design and provide for the center of interest. Make several quick studies and select the one you like best.

Transfer the sketch to the watercolor sheet, taking care to keep the same proportions as in the thumbnail. The subject can be outlined in pencil or ball point pen, with the line later becoming an integral part of the painting. Don't get too fussy with detail in this drawing, concentrating instead on the placement of large shapes only.

Begin flowing light colors on in large areas with a big brush. This is local color — the general color of the area being painted. Use big strokes and don't worry about detail. Wash in all sky and large shapes, negative and positive. Let areas dry before continuing, unless you purposely want them to run together.

Darker areas are added next, working from light to dark. Paint color and value shapes only — not leaves, boards, or windows. When these areas are dry, the details can be painted in with smaller brushes in darker values. Color areas can be altered by pulling color washes over them, and textures, line and characteristic features can be added.

Observe how shadows fall and stroke darker washes over these darker value areas. Use a similar grayed color for all shadow washes in the same painting, with slight modifications to satisfy local needs. This will tend to pull the painting together and produce a more unified result.

Don't overwork the surface! Don't add too many details! Don't scrub! Don't apply too many washes over each other, or muddiness will result! All the don'ts seem to apply to doing too much of something to the painting. Watercolors generally work best when kept simple, and an easy rule to remember is just that — KEEP IT SIMPLE.

If students tend to spend too much effort on details, try having them work in a partly darkened room or from a partially lit still life. Have them paint directly from slides shown in a partly darkened room so that much of the detail is wiped out by the light. Another method of eliminating the stress on detail is to limit the work to a single large brush, either flat or round. Emphasis can be placed on the large shapes (thus eliminating detail) by having students produce value studies of the subject, using large brushes, and working only from those to make the finished paintings.

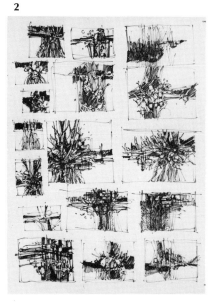

2

3

5

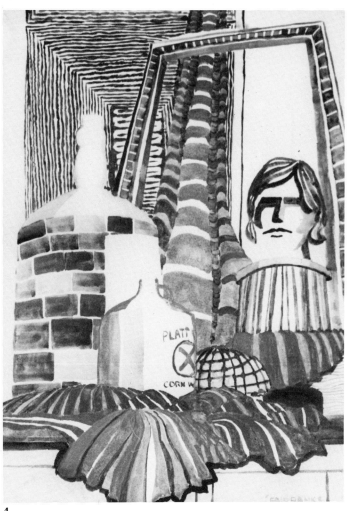

1 Put down the sketch first, add light values (saving the whites), then middle values and finally darks. Robert E. Wood's demonstration study lets you see the process in action.
2 A page of thumbnail studies that are simply shapes that can be developed into designs and paintings. Almost any subject matter can fit into many of them.
3 Initial drawing on watercolor paper can be in pencil or ball point pen. This one is done in fiber tipped pen to make it easier to see. Keep the shapes simple and the lines clean.
4 Still life is painted with a single flat 3/8 inch watercolor brush. Such a practice forces simplification because no details can be painted in. Watercolor on 24 x 18 drawing paper. Reseda High School, California.
5 Young artist is beginning her painting from a still life with boldly applied light values. No pencil lines are put down first in this direct method.

4

1 Stilt Houses. *Michael W. Green, watercolor and ink on cold pressed illustration board, 30 x 40. In this work, the artist mixes watercolor and India ink in his palette, to get dramatic value contrasts. Washes are clean, crisp and carefully controlled. Overlapping in places produces a feeling of depth. Courtesy of the artist.*

2 Gulls' Flight. *Jade Fon, watercolor, 22 x 29. Sky is a graded wash from darkest at the top to lightest at the bottom, with dark trees silhouetted against it. Near gulls are detailed but far ones are almost lost in the haze. Courtesy of the artist.*

3 *Detail of a Robert E. Wood painting reveals several wash techniques. On the left is a granular or sediment wash. Others are clear, some have spatters added, some are graded, others overlapped. This is an excellent example of juicy washes under complete control. Courtesy of the artist.*

4 *Model for this interesting watercolor was a lettered sheet of paper that was crumpled. Sketching and then painting it provides excellent study in shadow and lighting. Watercolor on 18 x 12 student grade watercolor paper. Reseda High School, California.*

1

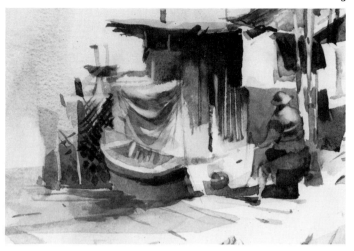

Studying several techniques is essential to understanding transparent watercolor. The paint can be applied to dry papers or to wet. Dry sheets lend themselves to line work, drybrush and a variety of washes, while dampened sheets are necessary in using wet-in-wet-techniques.

**Painting on Dry Paper:
Using Washes**

Pure wash paintings on dry paper are seldom done anymore, although in the past, British artists used the technique almost exclusively. Washes are large areas of color applied evenly to the paper, producing flat color shapes. Usually several loaded brushfuls are required to cover the area.

Easiest to apply are washes that can be laid on from top to bottom. Start on a slanted surface, and mix enough color to cover the surface. Use the largest brush possible and load it with the mixture, applying it quickly in long even strokes. Keeping the bottom of the wash very wet (leave a ridge of color wetness there) apply the next brushful. Repeat the process until the desired area is covered. Use the squeezed out brush or blotting paper to absorb the excess from the bottom of the shape, or else it will bleed back into the wash area as it dries, producing an unwanted cloud or sunburst.

By adding and stirring in more color (or another color) as the wash progresses, it can be graded to dark or to another color. By adding water to the reservoir with each stroke, the wash will be graded lighter.

Some colors, having heavier pigments, will settle in the hollows of the paper's texture, producing a sediment or granular wash. With practice (it has to be tilted back and forth), you can learn to control this phenomenon.

Clear skies and large flat shapes can be achieved only by using one of the wash techniques. Try each type several times to test your ability to control the application of such washes. Colored washes can be applied over dry washes to attain luminosity, contrasting shapes or to darken the previous wash. Be careful not to scrub or even to go back over a wash to touch it up while it is drying, because the smoothness will be irreparably damaged.

Large shadow areas are best shown by pulling darker washes over previously painted surfaces. These shadow washes (or glazes) will help unify the painting and by contrast will cause the lighter areas to glow.

1

Painting on Dry Paper: Line and Drybrush

If a wet line is run onto dry paper it will stay put, but if run onto a wet sheet it will dissipate into the wetness, producing a shape rather than a line. If it is necessary that the line read as a line (clean and crisp), be sure the paper is dry. Such lines can be drawn with any size brush or with pens or sticks, and can be done in waterproof India ink, or watercolor.

Artists might want the lines to bleed slightly, and will purposely draw them on damp paper. Such desired effects are achieved only with practice and patience. Fill a sheet or two with linear experiments on both wet and dry papers.

Drybrush techniques are generally used on rough paper, allowing the textural surface to do much of the work. Load a flat brush with watercolor and squeeze most of it out in the palette. Blot the brush on paper toweling or other paper and stroke it lightly across the work. The surface texture will grab some of the color, leaving a pebbled trail that reflects the paper's surface, with white flecks shimmering through the color.

Drybrush passages can be put on clean white paper or over a dried wash. Washes can be flooded over the drybrush work to fill in the white specks — or they can be left alone. Try working an entire painting using only drybrush, just for the experience and feel of the technique.

Not often is an entire painting done in drybrush, but it is used to express texture or show crispness against the foil of a wet wash or smoothly applied color. The technique, in most cases, produces a monotonous surface if it covers an entire sheet, but is excellent for foliage, coarse cloth, tree bark, rocks or accents.

You may like to experiment with drybrush on smooth paper to see the different qualities that result. Look over the drybrush glaze techniques of Win Jones in chapter eight, to see what one artist has discovered.

2

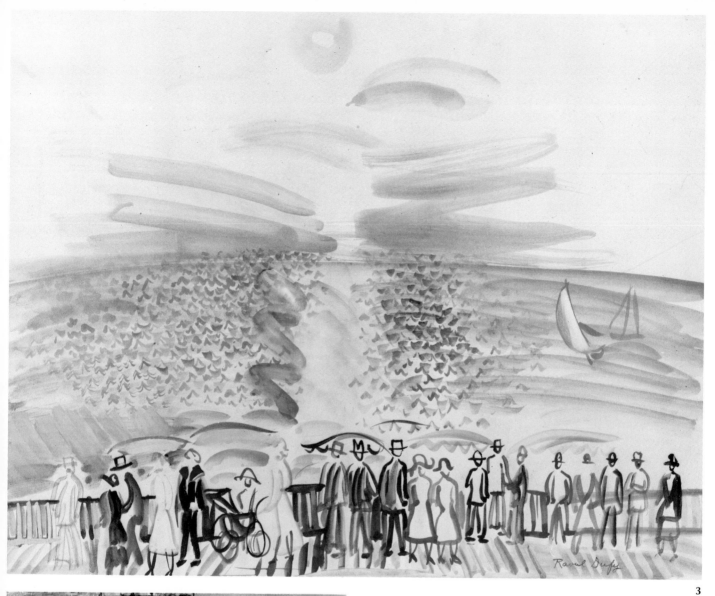

1 *Two watercolor sketches by Robert E. Wood show the contrast between drybrush (left) and wet-in-wet techniques. The former accentuates the texture of the paper and contains many white specks in darker areas. Courtesy of the artist.*
2 *Line is put down first with fiber tipped pen. When watercolor washes are run over the sheet, the line bleeds a bit, causing a softening of the hard edge. Painted from student models on 14 x 26 drawing paper. Leuzinger High School, Hawthorne, California.*
3 *Reflets de Soleil sur la Plage, 1925. Raoul Dufy, watercolor, 19 x 25. The calligraphic line is all-important to the artist's work. Remove the line and all that remains are a few soft washes. Courtesy, Los Angeles County Museum of Art, Mr. and Mrs. William Preston Harrison Collection.*
4 *Locks and Bolts. Eileen Monaghan Whitaker, watercolor, 16 x 22. Textures of the ancient wooden door and the rust covered lock are heightened with drybrush technique. The artist has chosen to paint only a small but fascinating part of a huge door at the San Fernando Mission. Courtesy of the artist.*

1 Two Women in a Garden. *Mary Cassatt, watercolor, 18¹/₂ x 13¹/₂. America's fine impressionist painter, known much more for her oil paintings, here boldly brushes out a watercolor sketch. Her brush heavily loaded with water and color, she swiftly delineates the figures and roughs in a background. Courtesy, Los Angeles County Museum of Art, Mr. and Mrs. William Preston Harrison Collection.*

2 Red, Red, Red. *Jo Liefeld Rebert, watercolor, 22 x 30. Great juicy washes are put down and allowed to dry. More loaded brushes are pulled over them until the desired contrasts and colors are achieved. Painting has a marvelous transparent quality, even in black and white reproduction. Collection of Dr. and Mrs. Ben C. Eisenberg.*

3 *Washes from loaded brushes can be applied cleanly and clearly over existing washes to produce luminous dark areas. Paper must dry between each application for this to happen. Watercolor on 18 x 24 student watercolor paper. Lutheran High School, Los Angeles.*

4 *Wet washes are applied, light ones first then darker, until the desired contrasts are reached. Some areas, in bright sunlight, are left white. Work was done from quick sketch made from a slide of the Kern River. Watercolor on drawing paper, 18 x 24. Lutheran High School, Los Angeles.*

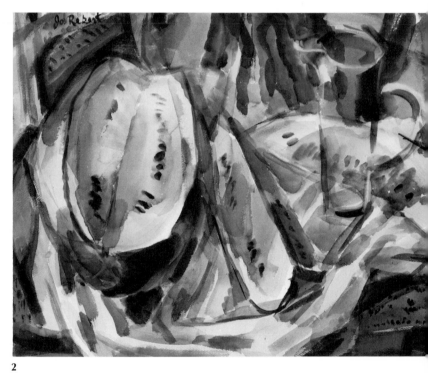

2

1

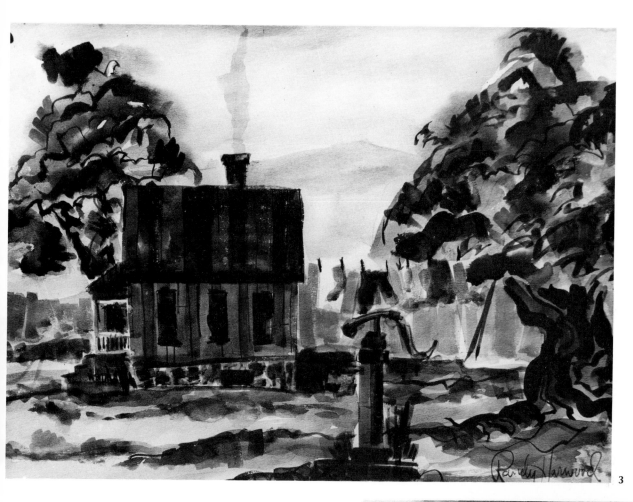

3

4

Painting on Dry Paper: Using a Loaded Brush

"Juiciness" can be achieved on dry paper simply by using a loaded brush; and actually, most watercolor is painted in this way. The sheer pleasure of flowing a luminous color onto the sheet of dry paper has to be experienced to be appreciated.

All the paintings on this page show the spontaneity and joy of using the medium. All were painted with large loaded brushes. Even though some detail might have been added later with line, the essential quality of each is that of large brushfuls of transparent color overlapping each other. This is really the essence of the watercolor medium: transparency; emphasis on the use of water; spontaneity; value contrast; a luminous white penetrating the color overlays; a rich and juicy surface.

Keep the brushes large and loaded to get these effects. But it can't happen unless the surface is dry before flowing on the next color. Keep the work simple in shapes and strong in composition.

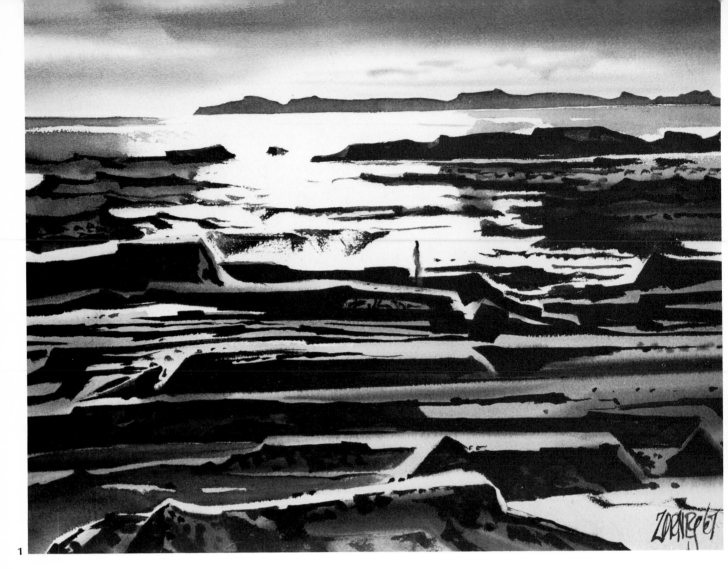

1

3

1 The Islands. *Milford Zornes, watercolor, 22 x 30. The artist is a master of controlled washes on both wet and dry paper, but it's the white of the paper that is important here. The glint of sunlight on water has tremendous impact, foiled by the dark-valued islands. Collection of Mrs. Hild Mohle.*
2 *Sacre Coeur. Helen Luitjens, watercolor, 22 x 15. Soft washes and hard-edged lines enclose islands of white paper, with the shape of the Sacre Coeur's dome becoming the center of interest. Courtesy of the artist.*
3 The Portal. *Gerald F. Brommer, watercolor, 22 x 30. Sometimes the white of the paper becomes part of the positive shapes, as in this white-washed Greek monastery. Pale washes were blotted with kleenex to suggest ancient textures. Collection of Mr. and Mrs. James Neville.*
4 Queen Anne's Lace. *Harold Mason, watercolor, 22 x 30. The design might call for leaving paper untouched in certain areas, resulting in a sort of unfinished feeling. Courtesy of the artist.*
5 *White snow, of course, can be "not painted" by letting the paper show. Shadows can make it feel rounded. Watercolor on 24 x 20 drawing paper. Lutheran High School, Los Angeles.*

2

4

5

Painting on Dry Paper:
Using the White of the Paper

White snow and clouds, whitewashed or marble buildings or white designed areas can't be painted with transparent watercolor, they have to be left. And leaving paper untouched is often more difficult than painting it. Decide what is to be white in the work and paint around it, not into it, leaving the white of the paper to radiate from the masses of color.

When left alone and surrounded by transparent color, the white shapes will take on the transparent quality of the rest of the painting. But planning must take place ahead of time, because student papers won't permit much scrubbing to wipe out unwanted color, especially in large areas.

Of course, some snow areas or white walls will have shadows, and light valued washes can be pulled over them. But the white that is left is the part that will sizzle.

White can be reintroduced into the work by overpainting areas with gesso or tempera, but often it looks added and not an integral part of the work. When white paint is used, it immediately adds an opacity to the paint, and eliminates the total quality of transparency. Often this doesn't matter.

Whites can also be left when wet-in-wet techniques are used, but the crispness and hard edges are not present. Look at these examples and note that all the white shapes or areas are pure paper, left untouched in the painting process.

Painting on Wet Paper: Soaking and Flooding

1

Perhaps the flashiest technique in painting is that of flowing rich colors onto a wet surface and watching the resulting mixtures, flows and blendings. Control of wet techniques takes much practice, but the rewards are often quite exhilarating.

The paper can be prepared in several ways. Heavy papers must be soaked for 10 minutes or more in a tub or large basin until limp, really wet all the way through. Lighter papers can be sponged with clear water or a colored wash on both sides. Some student papers get wet enough if water is simply flooded on with a large brush. Either evenness or unevenness of water saturation can be used to advantage by the young artist, depending on his experience in working on wet surfaces.

Papers can be kept workably wet during the painting process by laying them on a glass sheet, formica table or other non-absorbent surface. As the water evaporates and the sheet becomes drier, the edges of freshly-applied color will grow harder and more crisp.

If it is desirable to have the paper dry faster, lay it on a wooden drawing board or a sheet of blotting paper while working. Each artist has a pet way of speeding up or slowing down the drying time, and each is developed after years of experimenting.

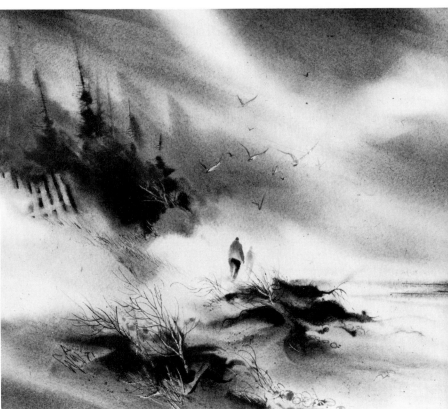

4

5

1 Quiet Interlude. *Paul Souza, watercolor, 22 x 30. The softness in this work is incredible, as colored washes are brushed onto soaked paper. The "sun" is one drip, allowed to expand. Courtesy of the artist.*
2 *Sponge can cover paper quickly with water or basic color.*
3 Rainy Day, 1927. *William Zorach, watercolor, 14 x 21¹/₂. The subject dictates wetness and watercolor responds beautifully. Wet paper causes soft edges in the early work and water spots, splattered on still damp washes, provide the feel of rain. Courtesy, Los Angeles County Museum of Art, Mr. and Mrs. William Preston Harrison Collection.*
4 *Flooded paper produces creeping effect when color touches it.*
5 Beach Figures. *Win Jones, watercolor on Dutch etching paper, 22 x 30. The special paper is very responsive to wet painting. As washes are applied on the wet sheet, they spread softly. Crisp-edged things (people, twigs) are added when dry and help emphasize the reality of the softness. Courtesy of the artist.*

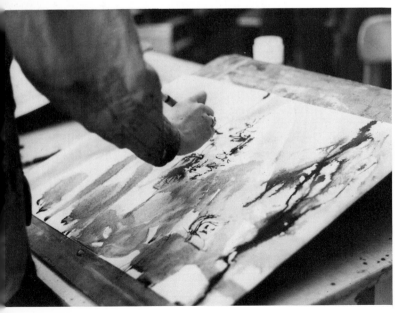

Painting on Wet Paper:
The Wet-in-Wet Techniques

Slurpy skies, large soft surfaces, billowy trees and surging surfs can all be flowed onto a wet sheet with a loaded brush. When running colors onto a saturated paper, be sure they are quite intense, since they will dry lighter. Remember that the water in the paper dilutes the color as it flows from the brush, so the fresh color needs to be put on relatively dry, if it is to stay in place. No verbal explanation can tell how it is — the process must be experienced.

The wet paper is usually worked on while flat, because a slanted surface will cause colors to run toward the bottom of the sheet. This could be desirable in some cases. Rough or textured papers generally work better than smooth.

Put the background or underpainting down first and add drier and more intense colors as the painting progresses. Combinations of paper wetness and intensity of color vary from minute to minute. A brush with very thick paint can make a fairly sharp line even on a wet sheet. Experiment with several small sheets to determine the best times to get the best effects. Most artists put the lightest areas down first, darkening the colors as the work continues.

As with dry brush techniques, not many paintings are made only with wet-in-wet techniques. The method produces best results when the exquisitely soft edges are contrasted with some sharp-edged areas applied to the painting when it is dry or almost dry.

Try some experimental studies on a variety of papers that have been soaked various lengths of time. Enjoy the happy accidents that occur and catalogue the results in your mind for possible later use. Many conditions, such as temperature, humidity and air movement will change the results, but some important generalities can be learned that will apply to most cases.

Important paintings using the wet-in-wet technique can be found throughout this book. Some artists might use this technique in only a part of the painting — or use it first, then overpaint or lift out after the initial work is dry. Again, the key word is experiment.

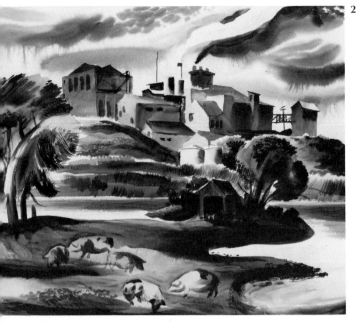

2

1 *Experiment with wet watercolor and wet tempera applied to wet paper. The surface is unbelievably rich and the textures seem impossible to produce. It's a way to learn about the medium. Paper is 12 x 18. Gardena High School, California.*

2 South San Diego. *Rex Brandt, watercolor, 21 x 28. The artist enjoys the wet-in-wet technique and uses it liberally in his work. Here the sky is allowed to run and bleed, yet still stays under control. Courtesy Los Angeles County Museum of Art, California National Water Color Society Collection.*

3 Fishing Rocks. *Gerald F. Brommer, watercolor, 14 x 18. Sky, rocks and crashing water are all soft-edged because of the paper's wetness. Several strokes were added when dry to help emphasize the wetness of the environment.*

4 Palace of Fine Arts. *Hubert Buel, watercolor, 22 x 30. Small sponges and a one-inch brush are used to work this surface in a wet-in-wet treatment. Crisp shapes and lines are added when dry. Courtesy of the artist.*

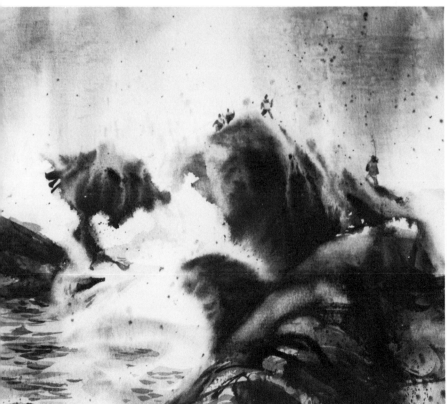

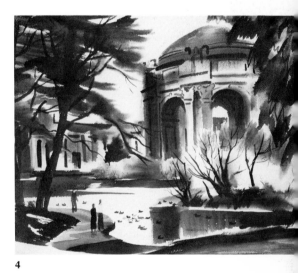

4

3

1 *White glue was put down first on a sheet of tagboard, and ink was spattered in some areas with a toothbrush. Watercolor and colored inks were washed over the surface and finally an ink line was used to outline various resulting shapes. Paul Revere Junior High School, Los Angeles.*

2 *Example sheets (these are about 24 x 18 in size) placed in the classroom can stimulate further experimentation.*

3 *Detail of a Robert E. Wood painting reveals several different techniques. The sky contains spatters from a toothbrush on both wet (see it spread) and dry surfaces. Light spots in the dark pole have been lifted with a brush, as have other lightened places. Courtesy of the artist.*

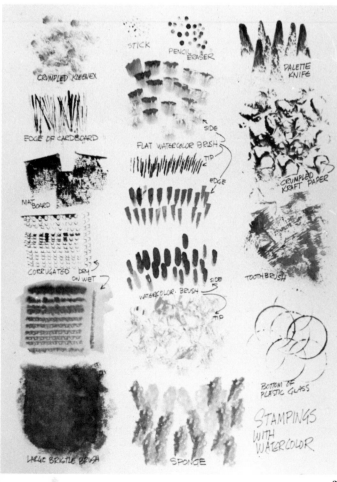

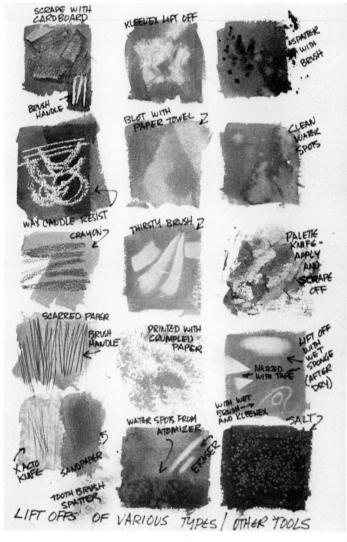

Other Techniques

Brushes can have other than conventional uses. They can stamp or spatter color onto the paper or they can splatter, drip and dribble. Other kinds of brushes might be tried, like toothbrushes, stencil brushes or house painting brushes. Other tools, like sticks, brayers, fingers or palette knives can be used to apply watercolor to paper. Other materials can be added to enrich the surface or the quality of the paint, as the next chapter shows.

Color can also be lifted from a wet surface, thus making the value lighter. Sponges, squeezed-out brushes, paper towels or crumpled facial tissue will do the job. Cardboard, razor blades or brush handles can scrape wet color from the paper. Any way to either put color down or lift it up might be used to enhance the painting or enrich the surface. Check out the artists in chapter eight to see what they are doing to augment conventional watercolor techniques. Try painting on a sheet of glass and "printing" the painting back on paper. Several overlay printings can produce exquisite textures.

Making Corrections

It is often said that a watercolor can't be corrected, but that is not true. Alterations in value or color can certainly be made, but results are best on high grade papers.

Dried color can be lifted or lightened by dampening the area with a soft wet brush and, after a moment, blotting or wiping it with a tissue, a sponge or a thirsty brush. Small areas can be lifted with a small brush or whole skies can be lightened or removed with a damp sponge. Sandpaper can be used to lighten the value of a dried wash, or a hard eraser can remove color from a restricted area. Less expensive papers cannot stand much abuse, so you will have to experiment with the ones you have available. Masking tape can be used to cover adjacent areas while some places are being sponged out.

You can make corrections, and then paint over some of them, but the secret to doing it successfully is that nobody should be able to tell that you made the correction. The corrected area must look as if it belongs to the rest of the painting in color and transparency.

1 *This large (30 x 22) painting is done from a student model. She was sketched in white crayon and ink on the drawing sheet. Watercolor washes provide the color and emphasize the resist. Hollywood High School, California.*
2 *Clutter and clash of neon lights and billboards can be colorfully shown in the wax resist technique. Heavy crayon is put down first, followed with washes of dark-valued watercolor. This resist work is 18 x 24. Lutheran High School, Los Angeles.*
3 *A series of experiments using only watercolor and crayon can produce dozens of swatches. Here, in a design class, several have been mounted in a layout problem. Overall size is 24 x 18, on various papers and boards. Lutheran High School, Los Angeles.*
4 *Expanding Space. Paul Souza, watercolor and crayon, 22 x 30. Landscape elements are drastically simplified and abstracted in this work. All the washes are flat, but texture occurs in several passages because of crayon that was applied first. Courtesy of the artist.*

IN AN AGE of experimentation and emphasis on unique effects, watercolor enjoys a distinct advantage. Because of its water content, it can be easily mixed with other water-containing materials. Yet that same aqueous quality causes it to be resisted by grease- or wax-containing media. Watercolor is attractive in its pure transparent state, but is equally attractive in combination with other media. Look at what some people are doing.

With Crayon or Wax

Wax crayon resists watercolor because of the antipathy of wax and water, and this phenomenon can be used to advantage in creating fantastic textural surfaces. Yet it can also be used in more subtle ways in portraits or landscapes.

Draw first with crayon and flow washes of color over the drawing, or put the watercolor down first and draw over it. Mix up the process or draw into the wet surface. Use white candles to make the drawing on white paper, and watch what happens when the wet watercolor flows over it. Try working with oil crayons, either over or under the watercolor.

Paint and draw and scratch or scrape the crayon surface. Add ink lines. Blot, scrape and paint. The variety of approaches is almost endless. Experiment on small swatches to see how much variety can be achieved in the class and really enjoy the process of exploration.

5

COMBINING TRANSPARENT WATERCOLOR WITH OTHER MATERIALS

3

2

4

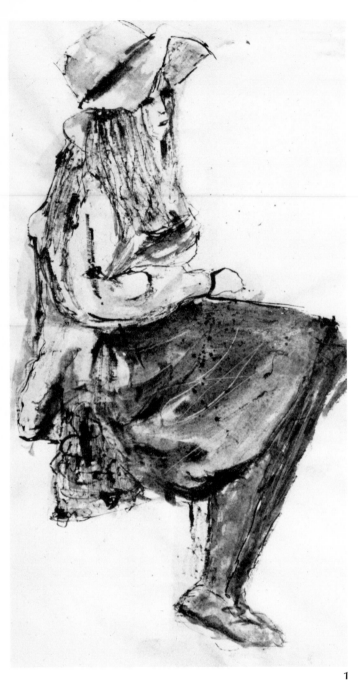

1

With Starch and Glue

Bold, yet transparent, effects can be achieved if watercolor is combined with starch or other heavy transparent substances. Flour paste was used with watercolor several hundred years ago, but now library paste and starch are easier to work with.

Put a bowl of liquid starch next to your water supply. Clean the brushes in the water and mix colors with the starch, using water to thin when necessary. Apply the mixture with stiff brushes or regular watercolor brushes. Palette knives, sticks or your fingers can also be used. Scrape out lines or shapes while wet. Draw back into the work when it is either wet or dry. Put a layer of starch on the paper and paint into it with a loaded watercolor brush.

Try these processes on smooth paper (finger painting paper) or rough (oatmeal or cardboard). Try working even on colored papers to see what happens. Fascinating textures and a very painterly quality are the rewards of such experimentation.

With Turpentine

Mixing turpentine and watercolor produces still another combination effect that can be useful as backgrounds or in experimental or abstract works. Using a housepainting or varnish brush, spread a layer of turpentine over the paper. Immediately, before it can dry, flow your color onto the sheet. As the turpentine dries, the mixing characteristics wane. Continued working of the surface will tend to cover up the effects of the mixing. Skies or other areas that can be left untouched, or areas in more abstract paintings, seem to qualify best for this combination technique.

1 *Pick up your wash and then some starch and brush it vigorously on the paper. A new painting feeling occurs. It neither feels nor looks like transparent watercolor, but it is. This 24 x 18 painting from a student model is done on oatmeal paper. Lutheran High School, Los Angeles.*
2 *Turpentine was first brushed liberally on a sheet of drawing paper, followed by equally liberal doses of watercolor wash. A slight resist occurs, with color beading up and forming interesting textures. The longer the work continues, the less beading of color occurs.*
3 *A large watercolor brush picked up color and water, then was dipped into a dish of starch and the mixture applied to drawing paper. Foliage on the right was manipulated with fingers, while the trunk and grasses were formed by dragging a stick over the wet mixture.*

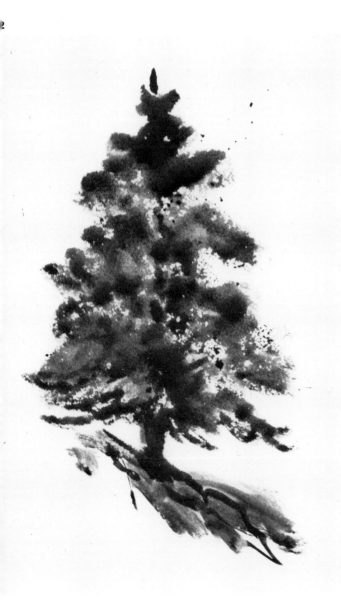

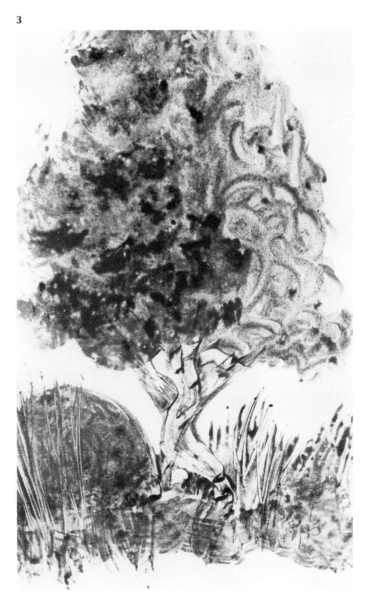

1

2

With White Tempera

Combining transparent watercolor with opaque white tempera produces gouache, an opaque watercolor. A student can experience gouache painting simply by dipping his brush in the watercolor box and mixing the paint on a palette with a bit of white tempera, then stroking it on paper. A pastel quality usually results, but deeper values can be obtained by careful mixing and experience. Ink lines might be used to add strength to the painting, if desired.

Opaque passages might also be used in combination with transparent paintings, but care must be taken to keep the parts visually compatible.

A large surface (sky or water) might be covered with a gouache coating, such as yellow-gold. When dry, paint into this area with regular watercolor. Some pulling up of color will occur, causing the entire painting to have a common tone. Fog might be worked in this way.

Spatters of opaque color might be used in snowstorm paintings or in trying to communicate the effects of a crashing surf.

1 A Slow Death for Seven Oaks. *Roland Golden, watercolor and opaque white, 22 x 30. Masses of leaves and some light tree branches are stylized and painted with opaque white added to watercolor. When put down over a previously laid dark wash, the leaves stand out dramatically. Notice how the tree changes values as it stands in front of the dark house (it is light) and then against the light sky (it is dark). Courtesy of the artist.*

2 Bearded king *is done with half-pan watercolor and ordinary white tempera, producing a gouache painting. Work uses transparent watercolor which, mixed with tempera, produces an opaque pigment. Painting is on 24 x 16 folio board. Lutheran High School, Los Angeles.*

3 Portrait of a girl *is outlined on 18 x 16 folio board with a brush and India ink. Gouache (watercolor and white tempera) is brushed on, irregularly overlapping the line to give it a weighted effect. Lutheran High School, Los Angeles.*

4 A branch full of leaves and buds *can provide material for an exciting search. This is carried out with washes, white tempera and stick and ink. The 24 x 18 painting emphasizes the contours, but tints of color are supplied with the gouache. Gardena High School, California.*

3

4

With Collage

Gluing papers of various textures or colors to the painting surface can produce some exotic grounds on which to apply color. Or the collaged papers might become important parts of the painting in themselves.

Added papers can be adhered with PVA glues or rubber cement, with the former being more permanent. They can be glued on any time during the painting process — before, during or after the watercolor is applied.

Textures can be added by using paper toweling, rice papers, or other papers with textured surfaces. Colored papers, magazine print or crumpled wrappers might be useful in adding color or shape. The variety of textures and uses is almost endless, but remember you are working with *transparent* watercolor and colored, textured or pasted areas will not be covered up by the paint. They must be incorporated carefully into the design.

1 *Paper towels are ripped and collaged to a 20 x 30 sheet of folio board. Watercolor and tempera (gouache) provide the subtle colors, but the texture remains the important item. Lutheran High School, Los Angeles.*
2 *Still life watercolor painting incorporates magazine type of various sizes for texture, boldness and some color. Linear treatment of cloth produces strong feeling of folds and drapes. 30 x 22. Reseda High School, California.*
3 Ambiguous Vastness. *Alexander Nepote, watercolor and collage, 30 x 38. Various white watercolor papers (and some black charcoal papers) are collaged to Masonite and painted with transparent color. The artist uses this technique to produce dramatic compositions, rich in color, value contrasts and textures. See chapter 8 for details. Courtesy of the artist.*
4 Fallen Giant. *Gerald F. Brommer, watercolor and collage, 22 x 15. Japanese rice papers of various textures are collaged to this work, while watercolor is brushed over the collage to provide color. The collage-painting process is repeated until the desired result is obtained. See chapter 8 for more detail on the method. Courtesy, Fireside Gallery, Carmel.*

1

2

3

4

1

2

5

4

With Inks and Stains

Colored inks and dyes are both transparent and intense and can be used in combination with watercolor. Often they can provide spots of concentrated color that may serve as points of emphasis. Some artists complete entire paintings using dyes or stains of various types.

India ink may be used effectively in watercolors (either in initial sketching or in superimposed lines), but the earth colors like sepia, burnt umber or raw siena might work better in providing line in the work. An entire watercolor can be washed over with transparent ink (yellow or orange) producing an overall tone to the painting (sunset or dusk).

Try wetting tissue paper and "printing" its texture on drawing paper. The stains produced might be incorporated into a larger watercolor composition or they may be manipulated to form a complete painting. Simplified landscape shapes (see the work on these pages) are easily made, but more abstract designs might be more compatible with this technique. Leave the result alone, or add watercolor, as desired.

1 Olympia 23. T. R. Wessinger, tissue stain and watercolor, 30 x 40. Wet colored tissue paper is pressed to white board in selected areas and shapes to produce dramatic composition. Watercolor is added in places to provide line and shape. Courtesy of the artist.
2 Much of the shading and texture is done with pen and India ink. Watercolor is brushed over the ink to provide value changes and color. Each flower is held in the student's hand and drawn separately, with each young artist producing his own bouquet. Work is 21 x 27. Nightingale Junior High School, Los Angeles.
3 Ink line is put down and tissue paper is wet and pressed to the paper. Resulting stains provide the color and texture in this 24 x 18 work on drawing paper. Gardena High School, California.
4 Beautiful textures are obtained by staining poster board with wet tissue papers of various colors. This detail of a larger work reveals amazing surface changes. Gardena High School, California.
5 Tissue staining is combined with watercolor to produce a simple but dramatic landscape feeling. Work is 12 x 18 on drawing paper. Gardena High School, California.

With Stop Outs

Blocking out lines or areas that should not receive color can be accomplished with stop outs such as rubber cement, Maskoid or Frisket. These materials resist the watercolor and can be removed again simply by rubbing with a finger, eraser or ball of rubber cement. Masking or transparent tape can be cut into shapes, if desired, and serve the same purpose.

The commercial stop outs, Frisket and Maskoid, can be easily controlled and fine lines are possible to put down with a small brush. Rubber cement is less predictable and more difficult to get in exact spots.

Care must be exercised so that the stop out technique doesn't become a crutch, or that the technique itself doesn't dominate the painting. Used with discrimination, the method can greatly enhance the work. Some students use stop outs, then spend excess time trying to disguise their use.

Put down the strips and dribbles of rubber cement and when dry, paint over them. When the color is dry, rub off the cement. Apply again over the watercolor; flow on more and wash and rub off. Repeat the process until the desired surface pattern or color is achieved.

White tree branches or lines against dark backgrounds, ropes stretching over water, waves, birds, people or abstract patterns can be masked off and appear white against the painted surface. Other colors can be added to these white shapes or they can be left alone. A few practice runs will benefit young artists before trying out the process in a larger painting.

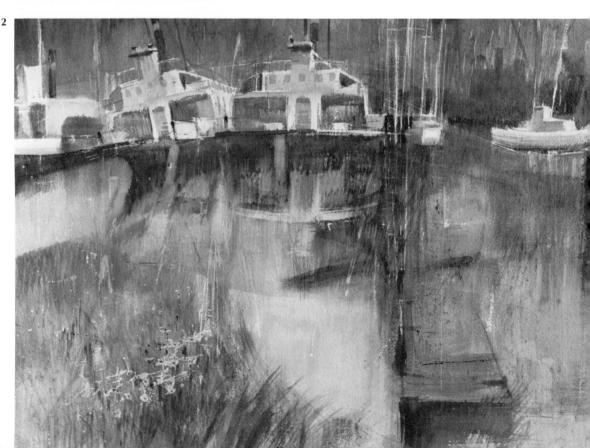

1

2

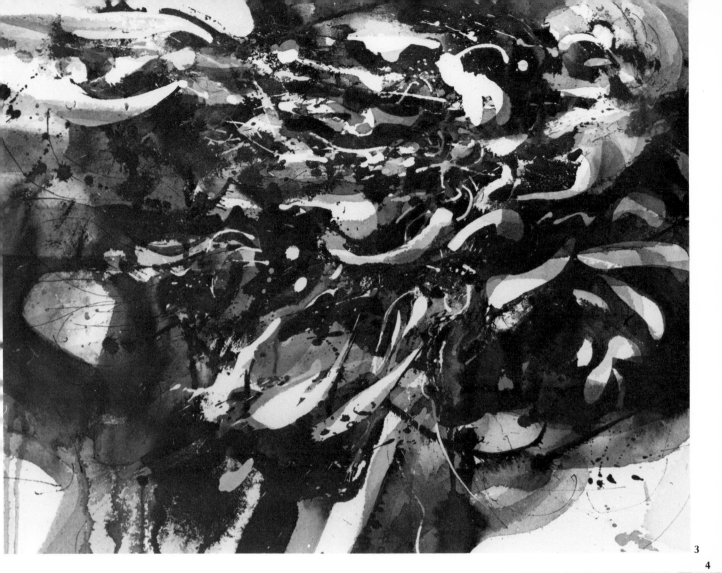

3

4

1 Surface Pattern. *Al Porter, watercolor, 15 x 22. The light lines, specks and spatters were blocked out with liquid Maskoid. Broad washes were brushed over and when dry, the stop out was removed. More washes completed the work. Courtesy of the artist.*
2 The Discards. *George Gibson, watercolor, 22 x 30. Thin light lines were stopped out with Maskoid. After the washes were dry and the Maskoid removed, more washes were added to keep the lines from jumping off the sheet and incorporate them more closely into the painting. Collection of Mr. and Mrs. Merrill Pye.*
3 Irresistible Forces. *Al Porter, watercolor, 15 x 22. Repeated applications of Friskit, wash and ink lines produce a rich textural surface. The artist has controlled a tricky technique to produce a dramatic and active composition. Courtesy of the artist.*
4 *Rubber cement is used as the stop out in this work, and watercolor is added when dry. Ink lines are applied after the stop out is removed. Painting is 18 x 24. Birmingham High School, Van Nuys, California.*

2

1

With Other Media

Every day, probing artists come up with new combinations, many of which will appear in later exhibits. It's fun to experiment and create new combinations, but be careful that these inventions don't become gimmicks that can't be shaken.

Add pastels, pencil, charcoal or chalk drawing and/or shading to the painted objects. Don't feel that any combinations can't be done; give them a try. Some fascinating results, done by students and professional artists alike, are shown on these pages. They can lead to more ideas on your own part.

On a Different Surface

Grounds can be altered to provide an exciting working surface. Papers can be used as they are, or they can be wrinkled, folded, soaked, sanded, scraped or otherwise abused — with each abuse causing a different effect on the paint. An interesting surface can be made by sponging off one old painting and working a different one over it. Or coat all or part of the paper with gesso (acrylic or cold water) and paint the watercolor over that. Shape a canvas in a three dimensional form or around another object, paint the surface with watercolor, and apply acrylic medium to hold it in place. And keep searching.

1 Beach, Acapulco. *Joseph Pennell (1912), watercolor and pastel on blue paper, 9³/₄ x 13³/₄. This small painting done on tinted paper with watercolor and pastel uses the chalkiness of the pastel to produce a rich surface texture. Courtesy, Los Angeles County Museum of Art, Mr. and Mrs. William Preston Harrison Collection.*
2 *PVA glue was squeezed out over some washes, with others applied over that. Scrubbing out and applying more washes can produce fantastic surfaces. Experiment is 18 x 12 on poster board. Leuzinger High School, Hawthorne, California.*
3 Dubrovnik Rooftops. *Gerald F. Brommer, watercolor and gesso, 22 x 30. Gesso was put down with a stiff brush to produce a textural surface on which the watercolor was painted. The feel of Dubrovnik's walls and chimney pots is simulated by the resulting textural appearance.*
4 Alcantara. *Miles G. Batt, watercolor, 30 x 22. The artist crumpled, folded, scratched and otherwise abused a sheet of 140 lb. watercolor paper, flattened it out again and began his painting. The folds, tears and scratches absorb color more readily than the surface of the paper, resulting in dark crinkly lines. This abuse process gives the painting a feeling of antiquity. Collection of Jerry and Virginia Levy.*
5 *Watercolor was mixed with polymer emulsion in this 14 x 10 experimental study. Ink lines were added to the work, done on student watercolor paper. Leuzinger High School, Hawthorne, California.*

3

4

5

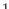

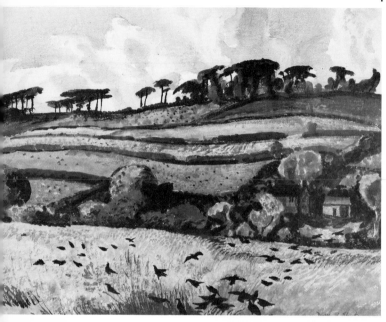

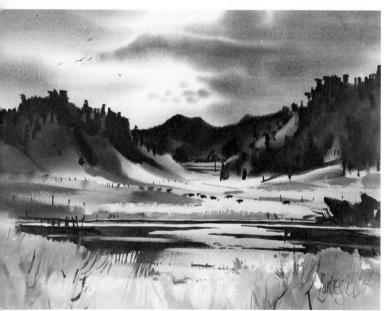

TO PAINT ANYTHING, you must first look at it — you must see it! Then, you put it down on paper. But what do you put down? You certainly can't draw everything you see in the painting, so you have to be selective. First notice the pattern that is created (repeats, textures, light and shadow). Then find the basic large shapes (dark ones and light ones) that make the composition. Put these simple shapes down on paper and then add whatever detail you need. Still lifes, landscapes, people, flowers are all done the same way. The following pages will help you observe and put down certain aspects of our environment that often show up as elements in paintings.

Skies and Clouds

Generalities first! Clear skies are generally darker above and lighter as they approach the horizon. Clouds generally get smaller as they approach the horizon. Skies generally have a luminous quality (not solid) and are generally lighter in value than the earth.

Skies can be soft or crisp, light or dark, designed or appear natural. Clear skies are made with *graded* washes (dark above, light below) and should never be flat looking, because the sky isn't flat. Tilt the board and apply the wash to dry or slightly damp paper. Be sure to have enough wash to finish the job.

Cloudy skies can be very dramatic or very gentle. Soft skies are brushed onto wet surfaces and crisp skies onto dry surfaces. Wet-in-wet skies are soft, particularly against a crisp row of hills or trees.

Clouds on dry paper should be drawn lightly with pencil (if that is necessary) and the darker blue or gray-blue brushed in around the clouds. The gray or yellow-gray of the clouds is brushed in the shadow areas and left alone. Keep the values light unless a dramatic effect is needed.

You can put the sky in first or leave it till later. Artists use both methods. If the foreground overlaps the sky, and is quite complicated, put the sky down first to avoid headaches later.

Because clouds and skies are constantly changing, they can be manipulated by the artist to satisfy the requirements of each painting. Several types of skies are shown here; others can be seen throughout the book.

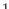

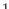

6

HELPS IN PAINTING

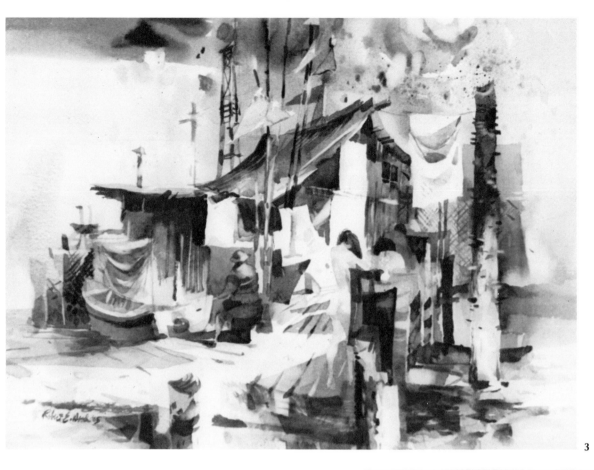

3

4

1 Fields near Middleton, Ireland. *Millard Sheets, watercolor, 22 x 30. Crisp clouds swirl above the Irish hillside. Water was put down in sky spaces, not in cloud shapes, and washes were run into the wet areas to produce the sharp edges. Courtesy of the artist and Dalzell Hatfield Galleries.*

2 Storm over Alton. *Milford Zornes, watercolor, 22 x 30. Strong but simplified middle ground composition is dramatically set against a soft wet-in-wet sky. Collection of Mr. and Mrs. Harold Ford.*

3 Wharf Space. *Robert E. Wood, watercolor, 22 x 30. The artist has designed his sky space with horizontal and vertical shapes, heightened with charged color and various spatters. This sky is not just negative space, but an active part of the painting. Courtesy of the artist.*

4 Wyoming Lake. *Douglass Parshall, watercolor, 18 x 24. In this active Wyoming sky you can "see" the wind blowing and swirling. The artist has put down washes and then scrubbed and rubbed them to get his effect. Courtesy of the artist.*

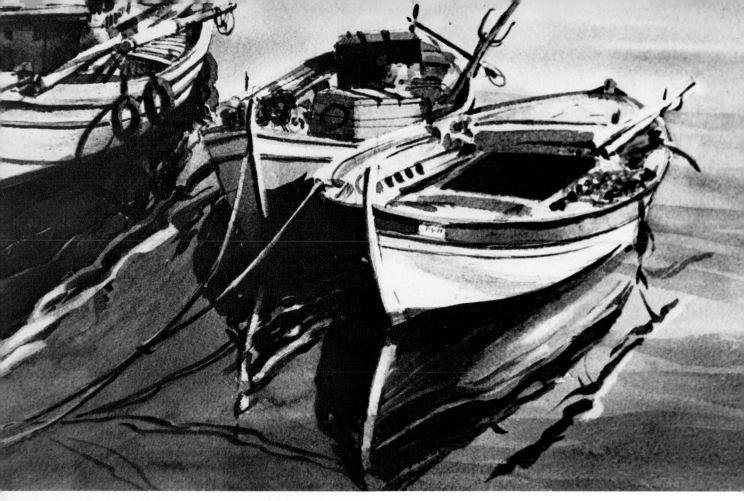

1 Heraklion Reflection (Detail). Gerald F. Brommer, watercolor, 22 x 30. Part of a larger painting, this detail shows one way of painting water — squiggly reflections of things that are above it. Broad washes supply the sky reflection and color.
2 Near Cisco. Francis Woodcock, watercolor, 22 x 30. Wet-in-wet technique is used almost throughout the painting. Water seems to be rushing so fast that it blurs the vision. Keep rushing water simple or it will look frozen. Courtesy of the artist.
3 Adirondack Stream. Frederic Whitaker, watercolor, 20 x 30. Running water can also appear still and slow-moving. For this feeling, broad horizontal strokes must be used, with few ripples showing. Courtesy, Old Town Galleries, San Diego.
4 Fishing Rocks. Gerald F. Brommer, watercolor, 16 x 20. Water and spray are sponged off to give soft edge to the spray. The rippling effect on the flat water is simply made with individual brush strokes. Collection of Mrs. Trevor Morris.
5 After trying several ways to paint water, this young artist used several stylized waves in the foreground. Sails and birds complete the composition. Watercolor and ink on 10 x 24 student watercolor paper. Paul Revere Junior High School, Los Angeles.

2

Water

Water, like clouds, is usually in motion so you must observe the way it looks at one instant, and catch that time on paper. One nice thing about water, it has rhythm in its movement and will generally repeat the sequence so you can catch that fleeting moment again . . . and again . . . and again.

Still water is like a horizontal mirror. Study its reflections and how it colors the reflected object. Also how the reflected light acts on the objects around it. Some water is colored because of its dirt content and might be yellowish or brownish.

Stream water moves and slows, tumbles and flows. Study its movements carefully and then paint a generalization of its movement. The brush strokes should follow the action of the water. Don't put down every rock and ripple, since rushing water looks best when understated. The lack of detail immediately brands it as a rapidly moving stream. The only way you might catch its "one moment" is to photograph it — and that might be a good way to work.

Open sea and crashing surf are in constant motion, but it is a recurring movement Because of the agitated surface action, there is little if any reflection. Open sea water has no color of its own (it's clear) but reflects the color of the sky overhead. The rougher the water the darker its color, but seas are usually darker than the sky above. Generally, the sea is darker up close and lighter as it recedes, unless sky conditions cause a variation.

Remember that the ocean is flat, so you should keep your brush strokes horizontal and not at various angles. Waves nearby appear greenish, as do curling rollers. The white spray, splash, caps and surf can be masked out at first to preserve the whiteness, or can simply be left unpainted. Hardly any part is pure white, so some light values will probably help round the crashing forms and declare them logical.

Simplify the movement and generalize the action. Put down *some* of the rocks, waves or splashes — don't try to incorporate them all. If painting water intrigues you, entire books have been written on the subject. Check the book list in chapter 9 for some suggestions.

3

4

5

1 Winter Chores. *Phil Austin, watercolor, 21 x 29. Winter trees allow you to see and study their structures, which are as characteristic as their summer shapes. Bare branches and twigs taper from thick to thin at the tips. Collection of Dr. and Mrs. Irwin Menachof.*

2 *A forest of trees cannot be seen individually, rather foliage and colors are massed together. Branches and trunks seem to belong to the group, not to any single trees. Watercolor is 24 x 18 on drawing paper. Lutheran High School, Los Angeles.*

3 Wailua River, Kauai. *Hubert Buel, watercolor, 22 x 30. Every new type of tree must be characterized with a certain brush stroke and color. This painting was done on location, and contrasts a stormy background with a warm sunny foreground. Wind blows the trees and the artist must pick up that feeling. Courtesy of the artist.*

4 *Robert E. Wood's demonstration sheets show growth systems (trunks and branches) and tree shapes (contours and sky holes) of several species near his home. Study trees for their characteristic structure and shape and then for textures and color.*

Trees and Foliage

There must be millions of leaves on some trees, so you simply can't paint them all. Simplification and generalization again become important, but looking and seeing are equally so. Each type of tree and each tree in that type is unique, no two are exactly alike. So, *look* at the trees you are painting.

Analyze the growth pattern — how do the roots, trunk, branches and twigs grow. Analyze the contour of the foliage in summer or the branch pattern in a winter tree. Put it down, generally, keeping in mind that the growth pattern is inside of it. Paint the generalized shape in the lightest tones you can see on the tree and, while still wet, run the darker tones into the clumps. Keeping in mind that the light source is above, leave the light values alone on top of bushy shapes. This variation in value in foliage clumps will suggest volume. Then watch for some detail, characteristic edges and sky holes.

Notice the trunk — its direction, thickness, texture — and how lower branches radiate from it. How does it emerge from the ground? Do major branches show through the sky holes? Do twigs extend beyond the edges of foliage? Put down characteristic leaf patterns in some darker areas.

Look at the surrounding grasses, rocks or snow — the tree's environment. Generalize their shapes and color. A broad golden area, with a few brownish strokes put on after it is dry, can suggest thousands of grass blades. The same is true of bushes and leaf clusters.

Foliage in a forest is massed together and must be painted that way. Single trees give up their individuality to the group. Mass the colors. Squint your eyes to eliminate minute detail. Add the patterns you see — lights first, then darks. Add characteristic trunks and branches Observe and put down the light pattern on the ground in a generalized way. Don't get carried away with detail. Use your largest brushes for most of the painting.

Work on these pages shows trees from close up and far away, in summer and winter, singly and massed, and of all types. Landscape painting books can offer you many pages of ideas for painting trees. But the best advice is to look, simplify the shapes and colors, add a small amount of characteristic detail, and stop!

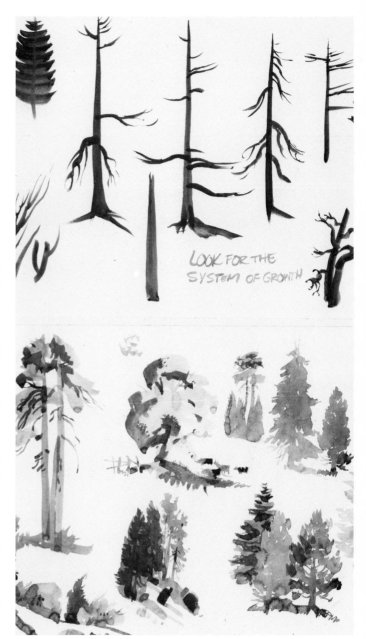

LOOK FOR THE SYSTEM OF GROWTH

4

1

2

Hills and Mountains

"Variations in relief" is how a geologist might speak of hills and mountains, but an artist sees these gigantic mounds in a different way. Hills can be soft, undulating and grass covered. Mountains can be sharp, hard and dramatic. Place them against a wet-in-wet sky and they will seem jagged. Allow the clouds to be of harder contour and the hills will become softer.

Every ridge and bump in the contour of the hill need not be painted. If you move a few steps, the mountain shape will change a bit anyway. Simplify the overall shape as well as the shadow shapes that give it form. (Notice the excellent examples on these pages.)

Values are *generally* stronger up close, lightening as the mountains run away from you. Trees, people, fences, houses, boats and animals may be used to show scale — to indicate how big the hill or mountain is.

Put down light values first (on either wet or dry paper) and add shadow patterns in big areas. Then add characteristic detail, but not much. Remember, the mountain is probably miles away, out of range for seeing any detail. Keep it simple!

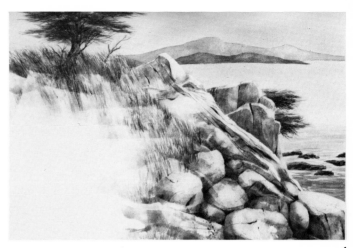

4

Rocks

From pebbles to boulders, rocks can be painted the same way. Sketch the general shapes (each rock is different), put the light values down first and add the shadow shapes while still wet. This gives a soft shading effect and will help show roundness. If the rocks are jagged, let the paper dry before applying the next colors. Rocks have hard edges, so initial contour shapes should be painted when the paper is dry.

Light comes from above, so values are usually lighter on top. Crevices and cracks, in or between the rocks, can show deep shadows. Spattering can add a granular texture. Blotting the wetly painted work with a cleansing tissue will produce dramatic rock textures on some papers. Make the initial color as dark as the shadows will be in this technique, because the tissue will lift out the color, leaving a light value on top. This process can be repeated two or three times if desirable. Paint in the darkest crevice shapes for depth, and the rocks will practically roll off the page.

1 Hills — Emil's Valley. *George Gibson, watercolor, 18 x 30. The soft contours of California's hills are captured with strength and solidity. Shadows are deep, but soft-edged. High-keyed foreground and sky help shift emphasis to the hills. Courtesy of the artist.*
2 Bora Bora. *Hubert Buel, watercolor, 22 x 30. A small sponge is used to work the wet-in-wet areas and sharp accents are added when dry. The painting, done on location, simply emphasizes the abrupt relief of the mountains, the dark shadows they cast, and the fluorescent quality of the water. Collection of South Pacific Air Lines.*
3 The Cliff. *Tyrus Wong, watercolor and ink on illustration board, 40 x 20. The artist's Oriental heritage helps him interpret rocks and cliffs in a calligraphic style. Directness and simplification typify such work. Collection of Mr. and Mrs. George Hayakawa.*
4 The Quiet Time, Carmel. *Gerald F. Brommer, watercolor, 22 x 30. The rocks are textured by blotting washes with crumpled facial tissue. Mood for the painting is set by the golden color which suggests a quiet twilight. Collection of Allan Hancock College, Santa Maria, California.*

3

1

2

3

People

Often figures are used in watercolors to show scale or relative size. But some artists like to emphasize the human figure and even paint portraits in watercolor. Because the aqueous medium is likely to produce accidental running and soft edges, accurate portraits are very difficult to make. But, whether used alone or in combination with other media, watercolor portraits or figure paintings offer an exciting challenge.

Remember that the principles of design apply to a figure study or portraiture as well as to a landscape. The value contrasts, center of interest, balance and other principles must still be incorporated.

Sketch to get your composition, draw lightly on the paper, flow on the light value areas, run in the mediums and darks, add a bit of characteristic detail if needed, and you should have your painting completed. Try working wet-in-wet and see what happens. Combine several techniques or materials. Put down broad washes and run a sepia ink line over the sheet to produce the detail. Experiment with papers and with tools.

Various artists use a variety of styles and techniques in approaching the painting of people. Washes, loose painting, careful studies, sketchy drawings, designed concepts and casual likenesses are all proper techniques. The examples on these pages and throughout the book exhibit extreme variety. All are different, and all immediately suggest ideas for further exploration.

In-depth study of the techniques of painting figures in watercolor can be found in several books — check their titles in chapter nine, if the subject interests you.

1 Mixed media can often spark new interest in portraits, because realism is not essential. This crayon and watercolor painting is in reds and oranges, done on 22 x 17 drawing paper. Birmingham High School, Van Nuys, California.
2 Camaraderie. Herb Olsen, watercolor, 30 x 22. Placement of the two figures is important in this painting, but note carefully the subtle value changes in arms and legs that create the roundness. Collection of E. C. McCormick, Jr.
3 Contour-like line in pen and ink augments some quickly applied washes in this study. Work is 14 x 8 on poster board. Leuzinger High School, Hawthorne, California.
4 Orange and Pink Vibration. Jo Liefeld Rebert, watercolor, 27 x 39. Through the artist's detailed process of simplification (see chapter 8) she has arrived at these shapes. Close-valued lines and shapes cause a sizzling color sensation in the work. Courtesy of the artist.
5 Painted from a magazine photograph, this painting is put down boldly and quickly, working from light washes to dark. The photo is not copied, but only used as reference for values, shapes and light. Done on 24 x 18 student watercolor paper. Lutheran High School, Los Angeles.

5

4

1 Cannery Row. *Donald Teague, watercolor, 20 x 30. The sharp angle of observation causes the need for dramatic perspective. Back lighting produces a glare off all flat surfaces, including the water. Textures and colors of the old buildings provide surface interest. Collection of Mr. and Mrs. Mark Thomas.*

2 Yugoslavian Village. *Gerald F. Brommer, watercolor, 22 x 30. Sunlight and shadow can provide excellent patterns when many buildings are clustered together. High-keyed sky and water provide a bright sunny foil for this coastal town. Collection of Dr. and Mrs. Albert Peters.*

3 Good Morning, Mother. *Ralph Hulett, watercolor, 22 x 30. Buildings can be painted close up as well as from a distance. Here the open door in a crusty and seemingly decadent exterior reveals a tropical garden and warm family associations. Courtesy of the artist.*

4 *Perspectives and features of houses or other buildings can be purposely distorted to create weird sensations. This watercolor and ink design is tilted and pushed out of shape for a desired effect. Work is 24 x 18 on drawing paper. Reseda High School, California.*

5 *A weekend assignment to "paint your own or your neighbor's house" can turn up some wonderful results. 18 x 14, watercolor. Lutheran High School, Los Angeles.*

2

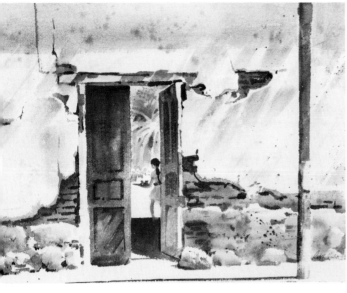

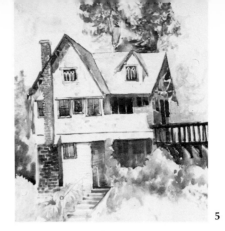

5

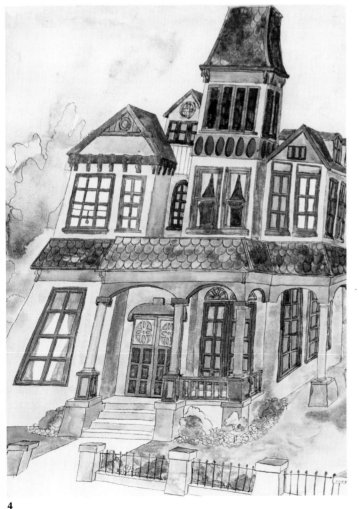

4

Buildings

Alone, massed, from close up or far away, from above, at an angle, familiar or exotic, buildings seem to hold a peculiar fascination for the watercolorist. Much of this penchant stems from the ability to work dark against light, and the luminous quality of watercolor washes. These easily simulate the sunlight on buildings and the reflected sunlight from one surface to another. Wall textures can be produced by dabbing, lifting, blotting, or overlapping sediment washes. Sharply edged buildings look very impressive against soft skies or water. Luminous transparent shadows can easily be pulled across several buildings, thus uniting the composition.

Not only on these pages, but throughout the book, buildings can be seen as important aspects of watercolor subject matter. A knowledge of perspective is essential to reproduce the solidity of structures, but distortion can also lead to interesting studies. Sketches are important in putting down the major elements of the composition. A few simple shapes are better than a lot of little pieces. Keep it simple.

From the sketch, photograph or site, select the essential shapes and pencil them on paper. Observe the overall local color of the buildings and wash it over large sections of the drawing. When dry, wash in the light shadow areas, followed when dry by the darkest washes in the deep shadows. Pull these dark washes over the previous local colors. Lay down the middle values in appropriate places and let them dry. No detail has been put down yet, just large bold shapes. Squint your eyes and observe the pattern on your paper; it should be similar to the pattern of your source of information.

With the largest brush you can still use, begin to show *some* selected detail — perhaps brick, stone or board textures, window shadows, cracks, roof tiles, etc. Don't try to put it all down or the effect will be cluttered. Leave something to the imagination of the viewer. Notice that in most of the watercolors shown here, the most detail is in shadow areas, since the glare of sunlight tends to wipe out detail in the lighter places. If the sky is put down later, turn the sheet upside down and run the washes *away* from the buildings. Add people or trees for scale, if necessary, and put in a small amount of characteristic detail; but still, keep it simple!

Still Lifes

Only a lack of space limited the number and style of still life paintings on these pages; others can be found elsewhere in the book. Still life techniques have no limit. They can be painted loosely or rendered tightly, patterned or washed freely, can be impressionistic or newly realistic, sketchy or finished. Emphasis can be on texture, color, form, pattern, shadow and light, or positive-negative relationships.

Any of the techniques discussed earlier are applicable. Still lifes are easily set up in the classroom and will remain stationary as long as the students need them. See chapter seven for more information.

Sketches can be made first, or painting can begin directly on the sheet. Using your largest brush, flow on the local colors first, working from light to darkest shadows. Wet-in-wet may be used early in the work, or the entire painting can be done crisply on dry paper. Line may be used or not, depending on the feeling of the moment, and/or the advanced plan.

Generally, detail should be kept to a minimum, unless a rendering is in order. Simplify, use large shapes, keep details selective and at a minimum, perhaps in the shadow areas or the center of interest.

Shadows and reflected light should be observed carefully, since watercolor is especially useful in depicting them. Pull unifying washes over objects where shadows are indicated —or where design needs strengthening. Lift or sponge out highlights, if necessary. Continue to stress contrasts in values (that is what makes a watercolor sparkle) and simplified shapes or forms.

1

4

2

92

3

1 Driftwood. *Perry A. Owen, watercolor on watercolor board, 30 x 40. A few small objects can be blown up to gigantic size and studied for color and texture. Strong value contrasts suggest bright sunlight. Courtesy of the artist.*
2 *A relatively simple still life can become a decorative delight when patterns are applied to everything. Watercolor wash, ink and collage are used in this 22 x 28 painting. Birmingham High School, Van Nuys, California.*
3 Reflected Image. *Jo Liefeld Rebert, watercolor, 28 x 40. Still life objects are treated boldly and with vivid color in this large painting. Careful composition is evident in the work. Although brush strokes appear hasty, they are put down with care. Collection of Brentwood Savings and Loan Association.*
4 *A few simple objects can be treated in several ways. Here the young artist uses a single-sized flat brush and applies all color in short flat strokes. Work is 10 x 13. Reseda High School, California.*
5 *Colored washes go down first (light, then medium, then dark) followed by a searching line which doesn't necessarily follow the washes (which are generalizations) but the contours. Noodling lines and splatters add textural interest. Work is 24 x 18 on oatmeal paper. Lutheran High School, Los Angeles.*

5

93

1

Animals and Birds

Like people, animals can be used to show scale in a painting, or they can become the central object. They can be set in their habitat or put against a simple background wash as a study in form or movement. They can be done realistically or with some distortion; can be rendered or sketched; done from nature, sketches or photographs.

Make quick sketches first to determine the characteristic shapes of the animal you are painting — how its legs bend, how long they are, how its head and neck work, how big the head is in relation to the body, etc. Get animal shapes from books or photographs, or better yet, go to the zoo. If a zoo isn't available, a museum with stuffed animals is a great place to draw them — and they won't move around or hide from you. Use the best of the sketches as the idea for your painting and transfer that feeling to the watercolor sheet.

When painting animals, the tendency is to try to put down every detail. But the warning again persists: Keep it simple. Of course, John James Audubon rendered his animals and birds in watercolor, including extreme detail, but that type of painting is certainly not characteristic of secondary school students. Use the largest brushes as long as possible. Think back on other paintings or experiments to determine what technique might best be used for feathers, shells, fur, hide, claws or hair. Or experiment with different approaches. Again work from generalizations to specific detail, putting the big shapes down first, then adding selected detail or generalized patterns. Keep the smallest brush in your box until the very end, and then use it sparingly — as for signing your name.

1 *A trip to the zoo can provide great stimulation. These colorful birds were done on location in watercolor on a 36 x 24 inch sheet of drawing paper. John Marshall High School, Los Angeles.*
2 *Single lines can define the roundness of the shape, as in this zebra painting. It is simply done, but effective. Watercolor on poster board, 10 x 14. Leuzinger High School, Hawthorne, California.*
3 *Animals can be painted in wet-in-wet techniques if they have soft fur. When the sheet is dry, accents or lines can be added. Watercolor and ink on 12 x 18 student watercolor paper. John Marshall High School, Los Angeles.*
4 *Quail Perch. Eileen Monaghan Whitaker, watercolor, 22 x 30. Several quail in the foreground are done in more detail than the rest, but the instinct to cluster together is easily felt. The artist uses a bridge from left to right to anchor her composition. Charles and Emma Frye Museum, Seattle.*
5 *Stuffed birds can come alive under an articulate brush. Watercolor wash and ink, 14 x 6. Granada Hills High School, California.*

5

2

burnell

3

4

Abstractions

Watercolor, alone or in combinations with other media, can produce excellent abstract compositions. Some might delight in pure flowing color, others might be crisp and clean; some tight and controlled, others loose and watery. The soft flowing quality of one painting might suggest movement, while others may seem static.

Some abstract watercolors might use nature as a point of departure (simplifying, abstracting, distorting, etc.), while others can find their reason for existing simply in emphasizing some of the marvelous qualities of the aqueous medium.

When abstractions are painted, the emphasis is on the design itself; and this must be carried off successfully or the painting fails. Look at some of the helps in chapter three. Examples on these pages show various approaches, but there are a multitude of others. Experiment and see.

1

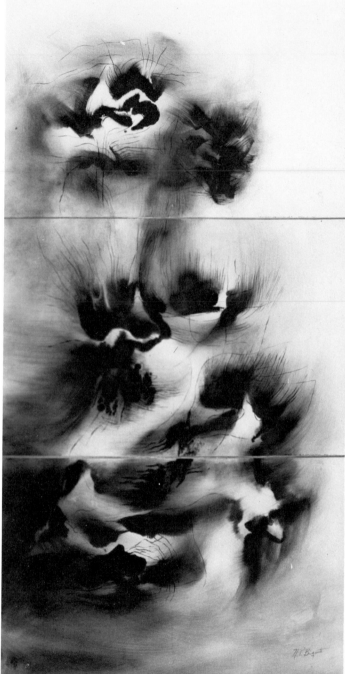

2

3

96

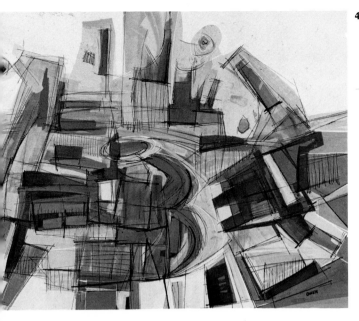

4

5

1 Edge of Space *(detail). Paul Souza, watercolor, 22 x 30. This detail shows the upper right quarter of the painting, containing some hard edge painting techniques. Masking tape was used to protect some areas while others were being painted. Tape will not work well on inexpensive papers, but it is worth a try. Courtesy of the artist.*
2 *Abstract shape was painted from sheer delight with the watercolor medium — just to see how it works. Study is on 24 x 18 drawing paper. Reseda High School, California.*
3 Upsurge. *Nick Brigante, watercolor and ink, 76 x 40. The artist uses soft floating shapes to express his message. Done in a set of three panels, the work seems to float upward with shapes and lines leading your eye in that direction. Courtesy of the artist.*
4 Blue Forms. *Perry A. Owen, watercolor, opaque white, India ink on illustration board, 24 x 30. Heavy squarish shapes are given a feeling of lightness by the linear overlays. The whole painting generates a feeling of restless activity. Courtesy of the artist.*
5 Hunt the Wild Boar. *Verily Hammons, watercolor and polymer matte medium on pebbled mat board, 21 x 24. The artist uses a unique approach to the subject with the circles seeming to rotate from left to right, carrying the action in that direction. Courtesy of the artist.*
6 Rock Figures. *Phil Dike, watercolor, 30 x 22. Rocks, surf and sky are recognizable, but all have been abstracted for the artist's needs. Dramatic rock textures, bold and sharp, are emphasized. Courtesy of the artist.*

6

1

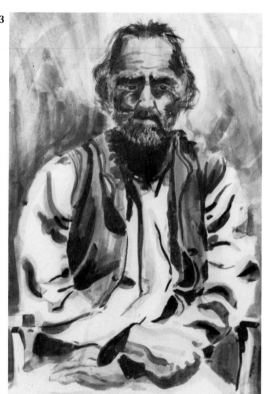

3

SECONDARY CLASSROOMS CONTAIN certain limitations in subject matter for paintings. Watercolorists are notoriously famous for braving severe topography and extreme weather in quest for just the right outdoor location. Time and distance preclude such excursions from most classrooms. But there are several sources of information that can stimulate productive young artists.

Photographs

To many teachers, the word "photograph" is questionable and doesn't belong in the artist's vocabulary. Yet, if the young artist remembers that he is creating a painting and not another photograph, then photographs can provide a lot of subject matter. Magazines, books and the student's own photograph might be used without leaving the classroom. Of course, such information is only second best, and students should know that.

Select from the photograph, as from nature, the principal parts of the composition. Don't try to include everything. Keep it simple. Make the sketch from the photo and don't refer to it again except to check values and characteristic detail.

If the tendency is too strong to copy exactly, take an intermediate step. Have students make sketches from photographs, as they would from nature, and then discard the photo and work from the sketch. Sometimes, as in the case of the insects on this page, photographs may be a very logical source of information.

Slides can also be used to advantage. Take several days and show landscapes or other slides for ten minutes each, having students make quick drawings in sketchbooks. Armed with twenty or more sketches, they can select and improvise from them.

Show slides in a partially darkened room, so all details are not clear. Students can work directly from them in the half-light, and not being able to see too clearly, will not be inclined to include details in their work. Only large areas and colors can be seen and used. Work quickly, with maybe ten to fifteen minutes on each. Such exercises will increase ability to see the large shapes and keep work simple.

Take a known work of art or a photo of a known landmark, and do it over in watercolor or in a contemporary style. Photographs can provide valuable information regarding form, light, texture and value, but remember to just use it as information and not something to be copied exactly.

7

WHERE TO LOOK FOR
SUBJECT MATTER

1 A recognized work of art (here it is Paul Cézanne's Card Players) can be used as a point of departure. Trace the outline and use that line to build the design. Work is 30 x 22. Reseda High School, California.

2 Watercolor was painted from a sketch made from a slide that was on the screen only ten minutes. Such quick sketches don't allow time for much detail, and the resulting paintings have a feeling of simplicity. On 18 x 24 drawing paper. Lutheran High School, Los Angeles.

3 Models like this old man aren't available to high school classes, so photographs must do. Simply remember not to copy but to use your own style, employing the source only for reference. 24 x 18, watercolor. Lutheran High School, Los Angeles.

4 Insect study can be done from observation, but will most likely be done from enlarged photographs. These excellent ones are done in watercolor on 18 x 24 oatmeal paper. John Marshall High School, Los Angeles.

5 Cliff Series, No. 3. Gerald F. Brommer, watercolor and collage, 22 x 30. A colored slide furnished the information on the rock cliff and the trees. Not all of the slide was used and some things that appear in the painting are not on the slide. Use your sources for information and delete or add at will. Courtesy, Fireside Gallery, Carmel.

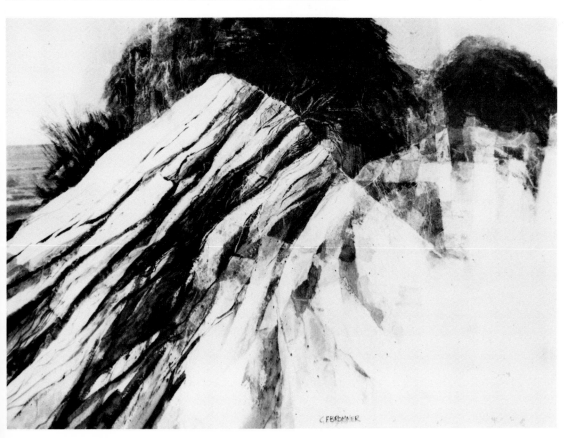

1 *The sketchbooks of Robert E. Wood contain visual impressions from his many painting trips. He has dozens of them just waiting to supply subjects for watercolors. Notice how he works across double 8½ x 11 pages. Courtesy of the artist.*

2 *These sketches are carefully done, others can be rapidly done, depending on your purposes and the time you have available.*

3 *Student is working on wet-in-wet phase of a watercolor, getting information from his sketchbook.*

4 *Cana in Galilee. Gerald F. Brommer, watercolor, 22 x 30. You can see both the sketch (done on location) and the painting (done in the studio). Sometimes the feeling might change, but here the feel and character of the sketch is transferred quite closely to the painting. Sketch is 8½ x 11. Collection of Ruth Byers.*

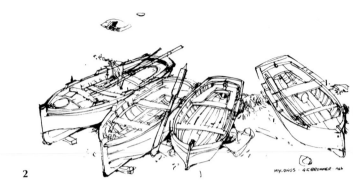

2

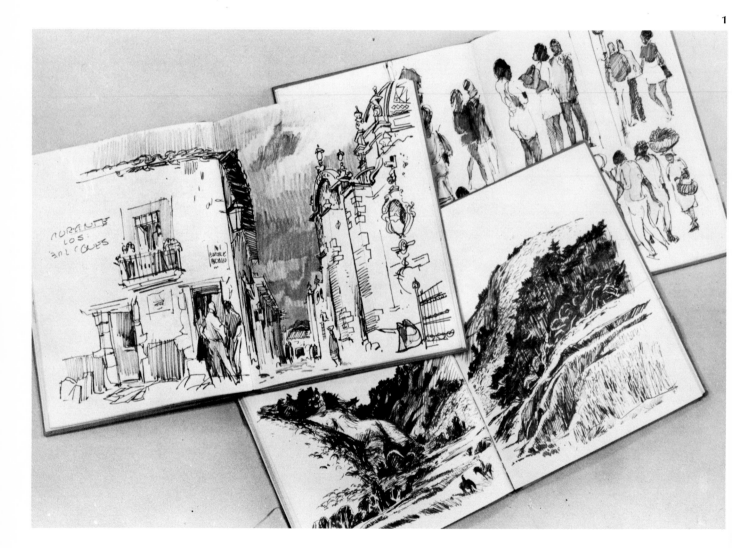

1

Sketchbooks

Working from sketches causes the young artist to interject his own feelings and ideas into the work. He is not confronted with a mass of details, but only a few lines, and he must add the values and details to complete the work.

Painting students should work in sketchbooks constantly, providing themselves with pages of paintable material. Sketch from remembrance or imagination, from locations or slides, in class and out. Translating some of these observations into paintings is both a challenging experience and a real joy.

Sketchbooks are also the place to store remembrances of things seen, which years later might find their ways into paintings. Next to nature itself, the sketchbook is the watercolor artist's best source of information.

3

4

3

1

2

Poetry and Imagination

Not all ideas for paintings come from visual sources. Often you can look inward and come up with ideas of your own. These might be remembered scenes, people or ideas; but they might also be images conjured up in your own mind, personal inventive statements put down for others to share.

Often such ideas need a catalyst to trigger the response. You can read a line from a poem (or make up your own poem) and illustrate or visualize it. The calendar, zodiac, circus, fantastic animals or weird people might trigger a few ideas. Students can't run to the library to research references for all these things, so they must begin to think inwardly and create some new images.

Once the subject matter is worked out, the painting process should fit it in style and content. It might be sketchy, linear, juicy or done with washes. It might be rendered to appear realistic or made loose purposely to seem unnatural.

Work out ideas for a color (what does red, yellow or violet suggest?) or a feeling (how would you paint anger or peace?) or a place (deep underwater, underground or on another planet). Look at the examples on these pages and use them as springboards to a whole new set of ideas.

102

1 *Illustrating poetry can provide subject matter, as a Japanese haiku did for this student. A book of haiku should keep a class in subject matter for quite a while. On 12 x 20 drawing paper. Lutheran High School, Los Angeles.*

2 *Weird organic blobs can offer excellent practice in shading with washes and color transitions. This monster eyeball is 12 x 18. Leuzinger High School, Hawthorne, California.*

3 *"Happiness", "Fun", "The Circus" can all be themes to stimulate action. Imagination and memory are exercised in this 18 x 10 watercolor and ink painting, done on student watercolor paper. Paul Revere Junior High School, Los Angeles.*

4 *Myth of an Island. Paul Klee, watercolor, 18 x 24. Klee exercised his imagination more than most artists of his time and came up with some delightful paintings. Most of his contemporaries were painting very realistically and couldn't understand his mind-stretching works. Courtesy, Los Angeles County Museum of Art, Myra Hershey Memorial Collection.*

5 *Fantastic space machine challenges the imagination. Not meant to be practical, working with such concepts stretches creative thinking. Ink line and watercolor, 10 x 10 on drawing paper. John Marshall High School, Los Angeles.*

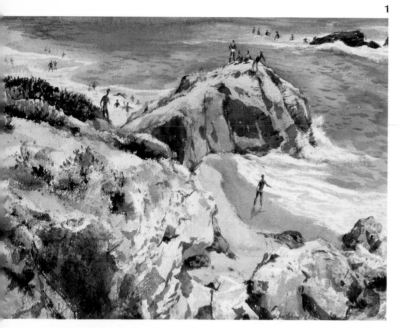

1 Beach Rocks. *George Gibson, watercolor, 22 x 30. A warm and sunny day at the beach is caught beautifully and simply. The artist, perched on a cliff overlooking the Pacific, placed the large rock shapes, put down the light values, then began working in darks and details. When it all felt comfortable, he stopped and didn't overwork any part of it. Collection of Mr. and Mrs. John Rothman.*
2 Sunday on the Bay. *Jade Fon, watercolor, 22 x 29. The artist has attacked a seemingly impossible subject — dozens of houses, sailboats, automobiles, telephone poles, etc. Yet, because he simplified to mere shapes and shadows, it is a success. With all that is portrayed, there is not one bit of fussy detail. Courtesy of the artist.*
3 *Robert E. Wood's four little demonstration studies show the effectiveness of simplicity. First large washes should be this simple and bold, then add whatever detail you think is necessary.*
4 Temple of Diana, Nimes. *Frederic Whitaker, watercolor, 27 x 22. Ancient stones receive simplified treatment. Background trees are especially simple to avoid attracting attention. Drybrush provides needed texture to the building stones. It is not a rendering with absolute accuracy; it's a successful watercolor painting. Collection of Mrs. Archer Huntington.*

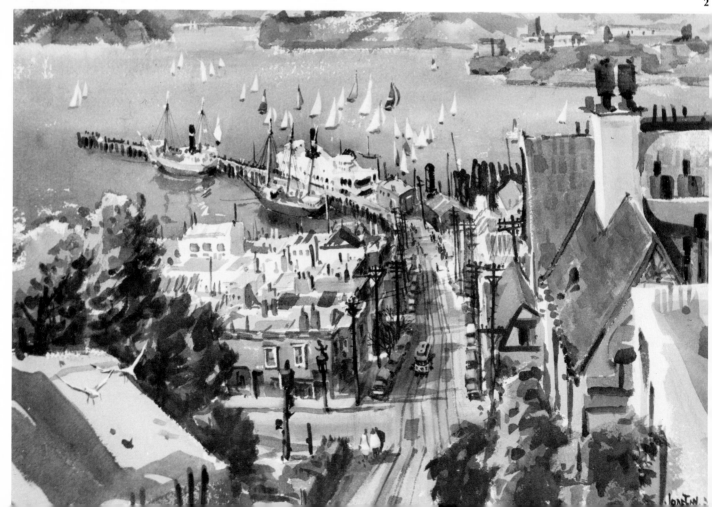

Painting Outdoors

Much of what has been said in other parts of the book regarding landscapes, water, mountains, skies, etc., would apply to painting outdoors. Not much field painting is done in secondary schools; but occasionally it does happen as a class, more often it is given as an assignment over a weekend.

Organization and simplification are the keys to on-the-spot painting. Look at the mass of visual material around you. You can't begin to put it all down, so you must organize what is there. Make a few thumbnail sketches before starting to paint. Select the outstanding feature (it will be your center of interest) and put it down, clustering other elements around it. Indicate darks and lights and check for good composition. You can do these thumbnails in pencil or with brush and color like the four that Robert E. Wood did on these pages. Keep it simple. Decide what you want to say and show, eliminating the rest.

When your idea is firm, sketch lightly on the watercolor sheet and get started. Each artist has his own way to get going, and it is always the way that seems most comfortable.

Colors dry more rapidly outdoors especially in the direct sunlight. Contrasts are also stronger because of the glare of the paper. Wear dark glasses to keep the white paper from shining too brightly, since this will keep you from seeing true colors and values. Be bold and work quickly.

When the scene is very complex, search for a pattern that will simplify the whole mess, as Jade Fon did in his San Francisco painting. Without the patterning of such subjects, the painting will fall apart in a multitude of little pieces like a shattered window. Look for the pattern in trees, water, clouds, earth, grass, walls, rocks. Analyze the pattern and try to find a few brush strokes that will simulate it.

Many artists complete their paintings on the scene while others finish them later in the studio. Others might only use the site-painting for reference, working out a studio painting from their field notes. All are tried and successful methods.

Some artists use a small frame or finder to help select the appropriate part of the entire scene. Whatever method works best for you is best. But the one single admonition will always apply — keep it simple. If you can't do that — at least simplify!

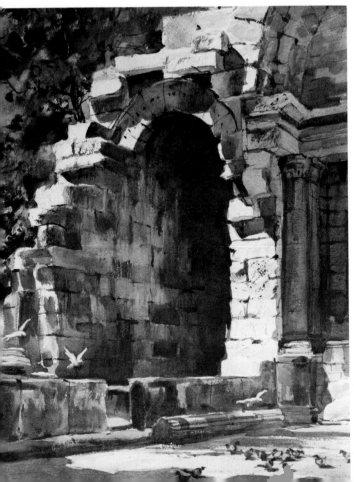

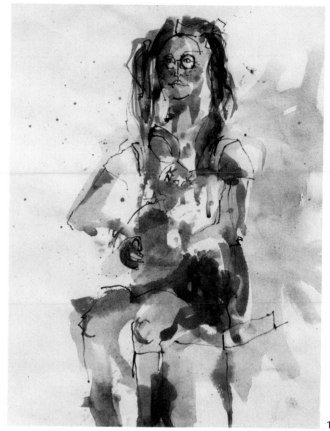

3

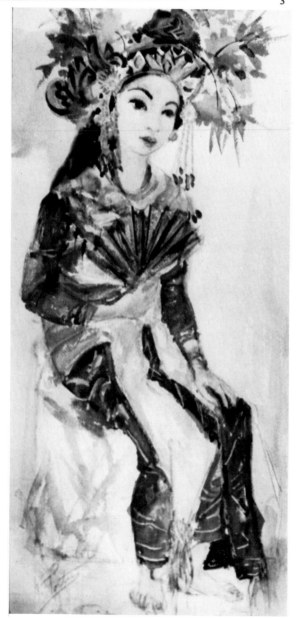

1

2

Still Lifes and Models

Excellent subject matter is readily available in the classroom in the form of student models and still life setups. Students can pose in dress-up costumes which can be very colorful, or in everyday wear. They can pose singly or in pairs, can read a book or play a guitar. Keep the styles of pose and dress changing from day to day so interest remains high. Seat models on the floor or on top of a ladder to change the perspective. Work directly from the model in wash style, keeping the work loose, perhaps running a stick and ink line in it to delineate some detail. Sketch from the model and later paint from the sketches. Make portrait studies from an extended pose. Unless something more detailed or finished is anticipated, *watercolor sketches* shouldn't take longer than a period — half a period is better, with some follow-up time at a later date. Use largest brushes for as long as possible, keeping everything as simple as possible.

Like working from models, still lifes can be used in many ways. Students can paint from selected parts of a huge still life or can make up small setups to use themselves. Work can have a design quality or can be sketchy — striving for looseness of application. The method of work will determine the length of time spent on the painting. Try to do a wet-in-wet still life or portrait, saving a few finishing touches till after the painting is dry.

Foliage and flowers, fruit and vegetables make excellent additions to an otherwise inorganic setup. They give it life and provide organic shapes. Use any of the techniques discussed earlier in the book, trying a variety of papers as you go along. Work generally from light to dark, but you can turn that around once in a while also and put some strong darks down first.

As in all watercolor paintings, constantly watch for value contrasts, simplified shapes, clean colors and good composition.

1 *An object like a guitar improves the concentration of young artists on the model. Watercolor wash with selective stick and ink line, 24 x 18. Lutheran High School, Los Angeles.*
2 *Still lifes can be realistically painted or stylized, as in this example. Colors, brush strokes and the simplified facial shadows are all the personal choice of the young artist. Watercolor, 24 x 18. Reseda High School, California.*
3 *Oriental Dancer. Katherine Page Porter, watercolor, 30 x 15. Models can dress up to help stimulate concentration and provide new subject matter. Notice the relaxed pose of the model and the simple treatment of the ornate headdress. Collection of the author.*
4 *Blossoms. Diane LaCom, watercolor, 10 x 14. You can hold flowers in your hand or set them up directly in front of you. But even at such close range, avoid trying to include every detail. Notice how leaves and petals are simplified. Courtesy of the artist.*
5 *Canteen is painted in pointillist technique, where the surface is built up dot by dot. Watercolor on 16 x 10 illustration board. Leuzinger High School, Hawthorne, California*

4

5

1 King Mountain. *Nick Brigante, watercolor and India ink washes, 68 x 34. Courtesy of the artist.*
2 Carmel Series, No. 5, Foggy Coast. *Gerald F. Brommer, watercolor and rice paper collage, 15 x 22. Collection of Mr. and Mrs. Thomas Hawley.*
3 Green Water. *Gerald F. Brommer, watercolor and rice paper collage, 22 x 30. Courtesy, Challis Gallery, Laguna Beach, California.*

EMPHASIS IN THIS BOOK has been on getting students to try watercolor in all its facets, some of its combinations, probing its possibilities. This chapter gives you an insight into some creative artists at work. It allows the artists to speak to you — to tell you why or how they do certain things — and shows you the results.

All eight men and women are nationally recognized watercolor artists, and have consented to share their techniques and ideas with you. Reading through the following pages will give you a rare look into the work and thinking processes of these people.

All of the artists work in a variety of ways at different times. They are innovators. These artists all love watercolor and its characteristic feel and look. But they also love to expand techniques and probe new ways to work. Their search has led to several remarkable techniques. But remember, none of these techniques developed overnight — they all took work, much hard work, and many hours of trial and error. But the results are worth the effort. Read and look and feel the excitement of the exploration. Most of the artists are also represented on other pages in this book. Check the index if you'd like to see further examples.

1

8 HOW SOME WATER COLOR ARTISTS EXPERIMENT

2

3

Tidal Pool. *Lee Weiss, watercolor, 26 x 40. Courtesy of the artist.*

Swamp Grass. *Lee Weiss, watercolor, 25 x 40. Collection, National Collection of Fine Arts, Smithsonian Institution, Washington, D.C.*

Lee Weiss

In recent years, as the size of my work has grown, I have found increasing need for surface enrichment. Watercolor's marvelous transparency can lead to shallowness without it. To gain this enrichment and, consequently, increased interest in the painting itself as well as in the image presented, I have developed a series of techniques designed to add texture and depth while retaining full transparency.

One method developed initially from an accidental discovery. Unhappy with a first attempt on a new, hard-surfaced paper, I turned it over on my formica-topped table to start over. This attempt proved no better than the first, so I peeled the paper off the slick table to throw it away and discovered that the still-wet pigmented surface on the first side had acquired some very interesting areas. I was intrigued with the possibilities and started a series of trials with this transfer process (basically a monoprint technique). I even flipped the paper several times.

First I wet the paper thoroughly, brushing in areas of color and compositional elements. Then I flipped that surface over onto the flat formica table and did the same on the back side. Then I pulled up the paper and flipped it again, picking up the pigment deposited on the table by the first with the second, etc.

I find this process can be repeated up to four or five times, each time laying on a new pigment or washing out, delineating a suggestive area, or defining a mass, but building continually. Color can be laid on color and dryer areas acquire distinctive textures. And these distinctive areas can stimulate the inventive mind. It's an exciting process that can be utilized for different effects, as I have done in the rather dryly worked "Decomposing Granite." (See color on page 40-H).

In "Swamp Grass" I began with large, open areas of color, pale gold to rich bronze. Into the very wet background I brushed the blades of grass with a 1 1/2" brush turning it from thin edge to broader stroke as the grasses "grew." In some areas I lifted blades of grass out with a nearly dry brush. The spots of water were flicked on with a big brush that had been squeezed quite dry. (The wetter the brush, the larger the flicked drops.)

As my painting progressed from large landscapes rendered on small paper to small aspects of landscape on large paper, I have become fascinated with the idea of looking *into* nature rather than *at* it. Small, beautiful things that are all around us, bits of moss in sidewalk cracks, an oil slick on a wet street, a rotted tree limb with twisted texture, lichen on a granite wall, fallen leaves in random patterns, the fluid rhythm of gutter water, all these are accessible to everyone. They suggest all there is to see, large or small, and allow us ever-new discoveries about ourselves in this world.

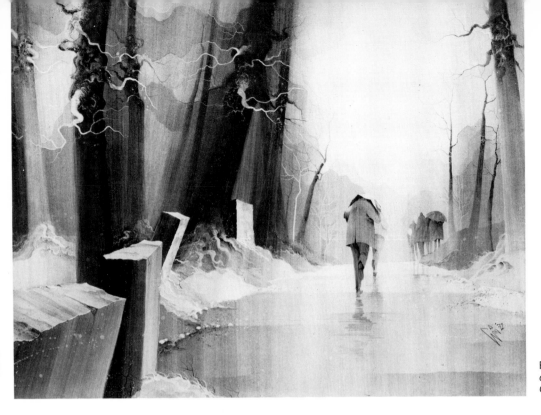

Rain Figures. *Win Jones, watercolor on smooth board, 22 x 30. Courtesy of the artist.*

Win Jones

Developing a watercolor through glazing or building up successive layers of color is not new, and the *drybrush glaze buildup* that I generally use in my work is simply an offshoot of that. The process does not capitalize on the spontaneity of watercolor as a medium as much as it exploits another distinct quality of it, translucency. For my work I use a medium weight hot pressed illustration board, a surface not generally considered receptive to watercolor because it lacks the absorbency required for the medium. Watercolor is one of the few media that is a stain into its ground as opposed to being a surface layer of paint; and by using a non-absorbent material such as illustration board, passages of paint already down are always subject to being smudged or lifted off by overworking. This board, however, despite its limitations, does have a perfectly smooth finish to it and allows me to get the very delicate detail and almost linear effect I like by pulling a very dry brush across the surface.

For most of my work I start a painting only after developing a number of small preliminary value and composition sketches. General spaces are then lightly blocked in on the board. Initially several extremely thin layers of color are put down with a large 2″ flat-edged brush, and these are gradually built up over a long period of time to the desired intensity. The hard edges of forms are controlled by using masking tape or pieces of typing paper cut and taped down to the desired shape. I try to work all over the painting rather than completing one section at a time. This enables me to keep control of the overall effect and also allows each section adequate drying time before another layer of color is introduced. Unless I allow five minutes or so between layers of color, I find that I tend to smudge areas of color that have already been set down. In some instances this is done intentionally in order to diffuse one form into another one. I generally have two or three large paintings being worked on at the same time; this, too, allows each painting more time to dry.

Early in the development of the painting I have to establish which shapes I will want to remain white (or lighter) and block those out. I never use any opaque white paint. Areas that are too delicate for masking tape or paper can be controlled by the use of Maskoid or Miskit. These materials are similar to rubber cement in their ability to resist paint but are water soluble when wet, which means that they can be applied like paint with a very fine detail brush. Once dry, color can be applied over the material and later simply rubbed off with one's fingers leaving a lighter area of color where the resist material was. Maskoid or Miskit can be put on or taken off at any time during the development of the painting, even over other color passages. Darker detail areas can, of course, simply be put in later with a similar small brush. From start to finish I will spend a full eighteen to twenty-four hours on a single painting. Most of the mystical, almost ethereal quality of my painting comes from attempting to exploit to fullest advantage the full range of transparencies of the medium.

111

Insect Migration. Nick Brigante, watercolor and India ink, four panels placed horizontally, total size 31 x 89. Courtesy of the artist.

Nick Brigante

My goal is to live with, observe, and absorb all phases of nature, and to create as she does — through labor and expression. The creative effort must have an interdependence of its parts; it must have emotional drive and energy. There has to be a strong positive relationship between the artist, his fellow man, and nature. The artist must have absolute control over all aspects of his creative effort — craftsmanship, materials, technique, design and the complete creative effort from start to finish.

The natural world remains the basis for inspiration and creative research, even though it goes through continuous change. New images are constantly evolving, changes take place, new sights, sounds, tastes, textures and smells confront us. And we need to create new ways of permanently visualizing these changes and new images.

This new nature immerses us in a moving element of atmosphere, heat, dampness and cold. We are touched and awed by the mystery contained in its depth and space. The artists' problem is now to visualize these sensations — to show others how we are affected by them.

For example, we experience a fast-moving, wind-blown fog.

We are bathed and feel the dampness of the thickened air rolling relentlessly in. A bright midday sun tries to stream through, producing intermittent translucency and illumination. The entire process produces fluid shapes, restless, advancing, contracting, expanding in all directions; changing, subsiding and reappearing. Such volumes break relentlessly against the mountains and explode, change course, disintegrate and seem to set the mountain itself in motion.

Noticing how this marvelously fluid sensation is the visualization of the changing forces of nature, I have tried to use it to express my feelings and observations about the daily newness of nature. I don't paint fog and sunshine, but I have tried to used their fluid darks and lights to express my feelings about all of nature. It's a new way of saying old things; it's the new image.

Nick Brigante paints much of his exploration using India ink washes, with thin glazes of watercolor over the underlying shapes. He has been greatly influenced by a constant study of oriental painting and freely allows that feeling to show itself in his work.

Gerald F. Brommer

Several considerations currently influence my painting — the marvelous organization found in nature and a fascination with surface enrichment. It is the latter that I would like to develop here.

An artist can simulate textures on his paper or he can actually adhere textural material to the surface. He can enrich his watercolor sheet by blotting, scratching, flicking color, dabbing, lifting or any other way that suits his purposes. But he can also add materials to his surface and thereby produce a richness and textural quality that is difficult to obtain in any other way.

I can't remember the first day I started gluing rice paper to my surfaces, but I thought about it for a while before actually doing it. I was familiar with the variety of Japanese rice papers, having frequently used them for printing woodcuts. I knew that the Japanese as well as some Americans were painting on rice papers, so I decided to explore a bit.

I glued some bits of textured white paper to my watercolor sheet, and when dry, pulled a loaded brush across it. What happened was fantastic. Textures actually seemed to grow like crystals while I was watching. The glue resisted some color and the papers absorbed in other places, producing a rich textural

feeling. After much trial and error, the methods and techniques have enabled me to explore textures in a different and exciting way.

I sometimes sketch first, but often not at all. Sometimes I paint first, but other times the collage gets done first. But this is a generalized pattern of working with rice paper collage:

Sketch the major shapes on a heavy paper (300 pound) or illustration board, and flow on some initial colors, more for value than actual color. When dry, glue pieces of various rice papers over the color, using a PVA glue or acrylic medium. I put the glue on the painting and stick torn bits of paper onto it, having a "palette" of perhaps eight or ten stacks of torn and cut rice paper. When dry, begin to flow colors over the surface, letting what happens dictate the direction to take in the work. You have some control over the development, but it is never complete. I keep working paint and paper over each other until the desired result is obtained. Only constant experimentation with color, intensity and application will help in understanding the process.

Even with the emphasis on the texturally enriched surface, that single element of design can't dominate the painting. The complete range of design principles must be observed to produce a successful work

Waterfall Series, No. 1. *Gerald F. Brommer, watercolor and rice paper collage, 22 x 30. Collection of Mr. and Mrs. John Garsich.*

Waterfall Series, No. 1. *(Detail.)*

113

Keith Crown

Sea and Pier — California. *Keith Crown, watercolor, 22 x 30. Courtesy of the artist.*

Like most artists, Keith Crown works in a variety of ways, because his subject matter affects him differently at various times. And subject matter is important to this artist. Two of his individual techniques are presented on this page, and he discusses each briefly; first his spray painting and then his white line painting.

My paintings are done directly from nature. My imagination, however, is the major factor in these paintings which are my poetic conception of nature. A deep understanding of the character of the medium is essential to a painter. In this work (*Sea and Pier — California*) I have employed almost entirely, an air brush. If the painting could be seen in color, a sensation of space would be evident *between* the blobs of sprayed color. Each layer of color has been allowed to dry, and the next blob is bigger, as layer by layer the image expands. The size of the blob is controlled by the distance the air brush is held from the paper. The closer to the paper the brush is, the smaller the splat of paint.

I call this second painting (*White Line Pier — Manhattan Beach, California*) a white line painting. No rubber cement, wax crayola, masking tape or stop out of any other kind has been used. A general color and value were determined at the outset. The general color varied according to nature only slightly. The value contrast is also slight, so that when the painting is complete, the most striking quality is the white paper left untouched between the painted passages. This method of painting is very strenuous. In a painting using stop out, the line achieved is an end in itself. In my painting, the white line is a by-product of space left between painted shapes, and the character of the line is very different from a stopped-out line.

White Line Pier — Manhattan Beach, California. *Keith Crown, watercolor, 22 x 30. Courtesy of the artist.*

Jo Liefeld Rebert

Plasticity is the most important aspect in painting. By plasticity I mean that all the elements must be in a state of flux or change until the total relationship becomes a unity. Without plasticity, invention is impossible, because clinging to certain parts of a painting (unwilling to destroy them for the sake of the whole) is often the reason that solution and content are never reached. As George Braque said, "The beginning idea is like a bud, developing into the flower (the completed work) which may have little resemblance to the bud."

No element can then be pre-determined, but is always dictated by the whole. Transparent watercolor is an excellent medium for "finding a painting." It is so readily destructible, so rapid a material for trying and seeing.

My current work has often been concerned with color vibration or new kinds of color relationships. [See color section of the book.] I usually begin with an idea that excites me, which might be derived from a past painting, a location sketch, or perhaps a composite of several things. Sometimes I make a large quick color sketch or several tiny pen sketches — anything to get me into the struggle. Then a long period of work and destruction follows. I use any medium necessary — watercolor, showcard, ink, charcoal, etc. — so I can rapidly sponge them off and change them to allow for a new flow of ideas. I do anything that helps me understand the content more, such as value analysis, linear rhythm drawings, etc. Much of this is done on tracing paper, because it saves time. Often I slide the painting under glass and paint on the glass, sponge it off and try something else. When it seems to be working in an approximate kind of way, I carry it further.

If it calls for a watercolor quality, I may use a mounted watercolor board or a paper which I can mount later. I keep everything flexible, allowing extra paper at the outer edge for expansion, if necessary.

When I paint, I work rapidly, and let the ideas flow. Then, when I run out of ideas, I sit down and look at the work for a long time. The more I look, the more I see. Looking is also painting, because emotional and intellectual qualities work together. It is impossible to invent or create anything without both.

Final painting, "Patzcuaro Symphony", is against the back wall. The work around it, from sketchbook to finished product, is all part of the creative struggle that the artist goes through with each work.

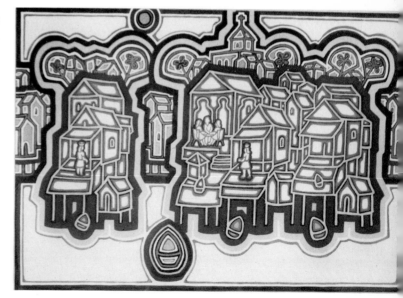

Isle of Janitzo. *Jo Liefeld Rebert, watercolor on watercolor board, 27 x 39. Courtesy of the artist.*

Alexander Nepote

Originally my watercolors were done on paper as "messy" preliminary colored drawings for the large semi-abstract oils. This was a process of correcting and changing by gluing thinner white watercolor paper over the basic sheet or peeling off when areas were several layers thick. About 1961, I developed a series glued on 1/8" Masonite, for better support, as regular watercolors. I use regular white glue and all kinds of thin rag papers. I do not use tissue papers, colored papers and only rarely heavy papers.

I first cover the Masonite board with a white paper. On this I sketch out a drawing in transparent watercolor to help me organize my thoughts. My paintings are abstractions from nature. They sometimes appear representational but essentially they are symbolic. In most of my recent work the theme is eternal transition. Transition is ultimate reality — the never-ending process in which things come into being, exist and pass away in the mystery of continuous change. Cliffs, grottos and the surrounding vegetation are images which make it possible for me to utilize the seen and the unseen, the known and felt and the specific and universal into a structure of relationships which express the process of existence — the power of transition.

After finishing the sometimes worked-over rough preliminary watercolor sketch, I start gluing on papers. In many of my paintings I have a dark upper corner or top symbolizing the unknown — the eternal mystery. This is achieved with an area of black Strathmore paper. Against this I glue a carefully torn shape; and when partially dry, I paint it with transparent watercolor. When this is dry, I add consecutive shapes in the same manner each time covering all the shapes with watercolor, thus building up several coats of transparent watercolor, giving a deep rich color effect.

In tearing the shapes I sometimes try to split the paper on one or two edges. When covered with transparent watercolor, the split area will appear darker giving a three dimensional effect. Dry washes of transparent watercolor can be developed further by sponge painting of slightly thicker color or sanded then tinted again to create special effects.

Several layers of paper glued on with slight overlaps before they are dried solid can be cut into with a razor blade or knife and peeled off in streaks which represent, for example, the erosion of a talus. When finished, each work is given three coats of acrylic matte varnish.

Transparent watercolors of this type have the advantage of the accidental not only in the flow of color but also in the process of paper manipulation. This technique uses the strength of the real overlapping to convey spatial effects and built up textures to create a surface patina which enriches the painting. The possibilities are unlimited — experimentation is the order of the day.

Interior Glow. *Alexander Nepote, watercolor and collage, 20 x 19. Courtesy of the artist and Emerson Gallery, Encino.*

Morris Shubin

Transparent watercolor can be put down on paper and also lifted off the paper. Morris Shubin works both ways, as these two examples show. It is in the lifting process that the artist has made substantial contributions to watercolor techniques. Let him explain.

In the first painting (*Sailmakers*) I followed my original sketches closely, but made the composition more interesting with the use of the negative area in the foreground. Leaving the white of the paper untouched, the action is forced to the upper part of the sheet. The figures were done in abstracted shapes, interlocked for greater unity. The impression of the large figure at the left-center was added for interest, but especially for more depth. Some lifting of color was used, but was kept to a minimum. I also refrained from using too many darks, keeping this watercolor high keyed and emphasizing the transparency. I used a limited palette of cool colors, with greens predominating the painting.

The second painting (*The Arches*) makes use of the sponging out technique [also see the color section of the book]. I put down underpainting with several washes in large abstract shapes, on strong watercolor paper. Some of these areas were lifted by scrubbing out with water and a sponge after the color had dried. Because of this lifting method, "accidents" happened that altered my original ideas. More shapes were added, more color was lifted.

Once I was satisfied with the build-up of shapes, I began strengthening values and contrasts. Figures were painted in for interest, scale and to give the structure more emphasis. The darkest darks and color accents were painted in last. The painting stresses not only the transparency of the watercolor medium, but also its workability. And it is all carried out with great concern for the principles of design as well as the technical application of the medium.

Sailmakers. *Morris J. Shubin, watercolor on mounted watercolor board, 30 x 40. Courtesy of the artist.*

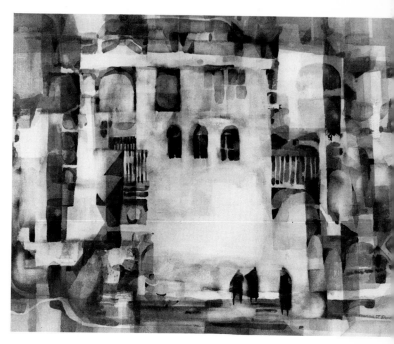

The Arches. *Morris J. Shubin, watercolor, 22 x 28. Collection of K. C. Bronson.*

1

IF YOU HAVE looked at the previous 117 pages carefully, you should be exhausted. Over 200 paintings are reproduced, many by extremely competent professional artists and others by young students searching for methods of communication. Every type of subject matter, many exploratory techniques and hundreds of thousands of brush strokes are shown.

The purpose in putting this all together was to show how transparent watercolor can be used in the art room. There is no single viewpoint presented, no "one best way" to paint, no rules or regulations. But there is encouragement to experiment, to try new and/or other ways of using the medium. Of course, the methods of the past are discussed, but they don't present the only answers. If you started reading this book to find out *how to paint watercolors,* perhaps your are disappointed because no formulas are given, no sure-fire ways are described.

The joy and pleasure of the creative act is in discovery: finding out for yourself what works and what doesn't work. If all of art were a matter of following directions, creativity would have no place in it. It is the searching, discovery and finding out what to do with the discovery that make painting a creative process. That is why artists must be creative people.

Several thoughts might help in the classroom approach to watercolor. Don't keep telling students that watercolor is the hardest kind of painting there is to do. You might just scare them out of trying to work with it. Encourage experimentation and searching, not attempts to produce masterpieces. Keep the atmosphere in the room relaxed by encouragement and talking to students. Young people get down on themselves when work doesn't turn out right the first time. Start over, wash out areas, paint over with opaque colors or line, but don't get discouraged. Read and paraphrase what Jo Rebert says about plasticity on page 115.

Do not evaluate student watercolors on the spot. Keep the work together in portfolios and evaluate it at the end of a unit. Even allow for discarding a piece or two, and adding a few things done at home or on location. Evaluate the growth process more than the work. Often this is best done by talking the portfolio over with the student. How does she feel about watercolor? What does he like about it? Does she understand the medium and the processes? These and other questions are as important to answer as is the ability to lay down a perfect wash. Do not pit all the students against the best technician in the class to arrive at grade distribution. Each student is an individual and must be evaluated as an individual — measuring

9 SOME FINAL THOUGHTS

his progress, not his standing when compared with another student.

Class critiques are valuable at times, especially when dealing with techniques. Students can see and learn quickly about value contrasts, limited palettes, use of color or the elements and principles of design in a group evaluation session.

Assignments may center around either subject matter or techniques. Have early lessons deal with specific phases of the medium, like washes, charging color or wet-in-wet. Keep lessons short enough to finish quickly, so progress is noticeable. Later the assignments can be more inclusive and necessitate several class periods. Generally, no watercolor assignment should take more than four periods to complete, often less.

When you have decided on the sequence and development of the watercolor program, look for ideas in the book that will help get the message across. Change, adapt, borrow or reject parts of them so your own personal needs are met. Not many exact assignments are spelled out in these pages, but hundreds of them are implied or are ready for adaptation to specific needs.

1 *Cubist techniques, transparency, contour continuation, stylization or emphasis on certain color combinations are all worthy of experimentation. Watercolor, 18 x 12. Reseda High School, California.*
2 *Space exploration and watercolor exploration can go hand in hand. Watercolor and ink line on gessoed board, 30 x 40. John Marshall High School, Los Angeles.*
3 *Painting problems can emphasize various aspects of a still life, like painting only warm hues, or only cool hues. This painting concentrates on the negative space. Watercolor, 24 x 18. Reseda High School, California.*

3

2

119

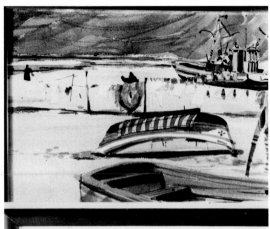

1 The upper painting is framed with only a narrow aluminum frame, which contains the glass, painting and backing board. This is a more modern framing technique. The lower painting is framed in the traditional watercolor method. It consists of a thin molding that contains a white mat, the painting and a backing board. The glass covers the mat as well as the painting and the mat keeps the glass away from the painting. In other frames the glass touches the painting.

2 The upper framing consists of a two-inch wooden frame, two-inch linen liner and a small painted lip. The lip and liner separate the painting from the frame proper. The lower carved frame has a one-inch tapered liner of natural linen. This is a common framing for oil painting, but in this case, contains glass, the watercolor painting and a cardboard backing.

3 Cathedral Town, Chartres. Gerald F. Brommer, watercolor, 22 x 30. Signature is at lower right but is in the painting, placed so it will not draw attention away from the work. Don't sign too large, nor too small. Collection of Mr. and Mrs. Elmer Wilke.

3

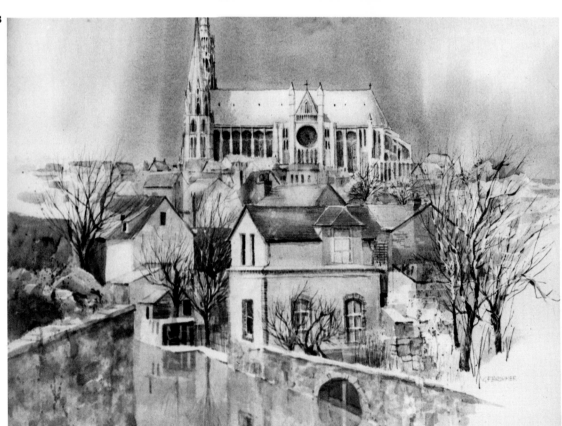

2

Signing, Matting and Framing

When the work is completed, it should be signed, and the location of the signature should be chosen with some thought. Do not put the signature in the "lower-right-hand-corner" or at the edge of the paper, because if matted or framed, the name will be covered up. Check the overall design, and keep the name in an unobtrusive spot — not in the middle of an open space where it will simply act as a center of interest. The signing signifies completion of the work, and the signature is part of the finished painting. It should not fight with the rest of the design.

Traditionally, watercolors are matted and framed, but this process varies with artists. A mat is a wide inner frame that separates the painting from the outside frame. Special pebbled and coated cardboard, usually in white, is most popular. Two to three inch mats are most often used, with some artists preferring a wider margin at the bottom of the mat.

The opening in the mat board is cut with a mat knife, razor blade or special mat cutting tools. Often they are beveled to present a thicker appearance and a neater edge.

Several methods of keeping the painting in place are used. The mat can be backed with a supporting cardboard, the painting being taped to this second board. The mat is then hinged to the board and not fastened to the painting at all. The painting can also be taped directly to the matboard. If framed, this need only be done at the top of the painting, to allow for expansion (without buckling) of the sheet during atmospheric changes.

Framing around a mat is usually narrow and simple — the traditional presentation for displaying drawings. Many contemporary watercolorists frame right to the painting, without use of a mat, similar to the framing technique for oils, only a linen liner separating the frame from the painting.

Watercolor paintings are also traditionally presented under glass, a necessity to protect the painting from dirt. Since watercolor paint is resoluble in water, even after years of being dry, it is extremely difficult to clean if it once gets dirty. The paper and paint are as permanent as other media, if not more so, but the resolubility presents a cleaning problem. This is the purpose of the glass protection. Some artists spray a varnish or fixative on the paper to make it waterproof, eliminating the need for glass. Other artists, disliking the glare of ordinary glass, make use of an etched or non-glare glass to protect their work.

Markings. *Harold Mason, watercolor, 22 x 30. The artist has signed and dated his work in the lower right area of the painting. It fits right into the design and concept of the work. Courtesy of the artist.*

Other Aids

It is true that you learn most about watercolor by painting watercolors, but sometimes there are problems that student and teacher just can't solve together. It is then necessary to search out other sources. Films and slides can help; other books can be brought into the classroom. The list of aids is monumental; a few, emphasizing watercolor techniques, are presented here.

Films

BRUSH IN ACTION International Film Bureau. 11 minutes, black and white. Demonstrates round and flat brushes and what can be done with them.

BRUSH TECHNIQUES Encyclopedia Britannica Films. 11 minutes, color. Eliot O'Hara demonstrates portrait painting in watercolor techniques.

PAINTING AN ABSTRACTION Encyclopedia Britannica Films. 11 minutes, color.

PAINTING CLOUDS Encyclopedia Britannica Films. 18 minutes, **color.**

PAINTING CROWDS OF PEOPLE Encyclopedia Britannica Films. 11 minutes, color.

PAINTING REFLECTIONS IN WATER Encyclopedia Britannica Films, 11 minutes, color.

PAINTING SHADOWS Encyclopedia Britannica Films. 11 minutes, color.

PAINTING TREES WITH ELIOT O'HARA Encyclopedia Britannica Films, 16 minutes, color.

PAINTING WITH CALLIGRAPHY Encyclopedia Britannica Films 12 minutes, color.

> All these paintings use the skill of Eliot O'Hara to demonstrate the techniques and methods of the watercolor medium.

WATERCOLORS IN ACTION International Film Bureau. 18 minutes, color. Ralph J. Rice demonstrates methods and techniques.

WATERCOLOR LANDSCAPE M. Grumbacher, Inc. 23 minutes, color. Rex Brandt shows wash, dry brush, line and wet-in-wet techniques.

WORKING IN WATERCOLOR International Film Bureau. 18 minutes, color. Emphasizes experimental approach in high schools. Development of personal style.

THE WORLD OF ANDREW WYETH American Broadcasting Co. 25 minutes, color. Available from International Film Bureau offices. Shows subject matter and techniques of this painter, including his dry brush watercolor paintings.

Filmstrips, Loops and Slides

If students need exposure to professional and/or historical watercolorists, film strips or slides might be the answer. Slides of watercolorists are available from various museums and companies specializing in such presentations, and individual artists are listed in many slide collection catalogues. Perhaps your local museum has a slide lending library that you might use. Some items of interest that are available include:

EDUCATIONAL AUDIO VISUAL, INC., Pleasantville, New York. Filmloops in color, each 3 to 5 minutes long:
> WATERCOLOR: THE WASH
> WATERCOLOR: CALLIGRAPHY
> WATERCOLOR: SPONGE MANIPULATION
> WATERCOLOR: BRUSH MANIPULATION

ELEMENTS OF ART: COLOR SERIES. BFA Educational Media, Santa Monica. Five 8mm filmloops about mixing, intensity, color schemes, etc.

WINSLOW HOMER. Educational Dimensions Corp., Great Neck, New York. Color, sound, 16 minutes. Some oils but many watercolors of the great American master.

WINSLOW HOMER. Sandak, Inc., New York. Slides of the retrospective show of the artist's work at the National Gallery in 1959.

JOHN MARIN. Educational Dimensions Corp., Great Neck, New York. Color, sound, 17 minutes. You'll see why Marin is credited with making watercolor a major American medium.

Magazines

Most art magazines run articles on watercolorists and some of the historical developments of the medium, but *American Artist* consistently features watercolor In fact, they have a watercolor page, where each month a different artist is featured, with photographs and copy, explaining his technique in great detail. A subscription and monthly clipping will develop a fat watercolor file in a short time.

Travel Exhibits

Watch your local museum for travelling shows of American watercolorists. Or you might book such a show for your school. Several groups initiate such shows, with one of the best (featuring many watercolor exhibits) being the Old Bergen Art Guild, 43 West 33rd Street, Bayonne, N. J. 07002. Get your city library or college gallery to book a show if you don't want to try it. Cost is minimal, and artists are excellent. Addresses of other such groups can be obtained from your local museum.

Societies

Watercolor societies still exist, even though they were started in England to promote watercolor and perpetuate the medium. Many groups survive in America with some being national in scope. They have local exhibits, travel shows and educational programs that might be of interest to you. Call your chamber of commerce or a local watercolor painter to find out what is available in your area. Major national groups include:
> The American Watercolor Society, based in New York
> The California National Water Color Society, based in Los Angeles
> The West Coast Watercolor Society, based in San Francisco

Dozens of state and local interest groups round out the array of societies.

Museums and Galleries

Many major museums feature regular exhibits of watercolors, some even sponsoring national watercolor competitions. Check your museums to see what their programs include. They also might be able to lead you to some other sources.

Artists

Watercolor artists usually are very interested in keeping the medium alive, and will give demonstrations to local art groups. Perhaps one would demonstrate for your class, or you could take your group to see him at work. You might borrow a few works from local artists to use as examples in the initial development of your watercolor unit.

Watercolor Books that Can Help

Literally dozens of books are on the market, written by America's top watercolor painters. Each has points that are extremely helpful, because each artist tries to show the best way to get exciting results. If you need demonstration books showing how to do certain things, many of these books will contain the answers. Some present a series of lessons, others allow for more personal exploration, and still others emphasize the personal approach of the artist-author. Your art room library (or at least the school library) should include a number of these, for reference and help.

Watercolor Techniques

ACRYLIC WATERCOLOR PAINTING Wendon Blake. Watson Guptill Publications, New York. Creative expression is emphasized as the author explores the use of acrylics in watercolor techniques.

WATERCOLOR LANDSCAPE Rex Brandt. Van Nostrand Reinhold Co., New York. Effective book that teaches a bold style, emphasizing direct response to nature. Also how-to-do-it.

WATERCOLOR TECHNIQUES Rex Brandt. Van Nostrand Reinhold Co., New York. Question and answer method is effective as are a number of practical painting assignments. Excellent.

WATERCOLOR, A CHALLENGE Leonard Brooks. Reinhold Book Corporation, New York. Discusses and demonstrates new and traditional methods of watercolor painting.

DRAWING AND PAINTING THE CITY Mario Cooper. Reinhold Book Corporation, New York. Excellent examples in watercolor and drawings of cities around the world. Design, composition and techniques.

FLOWER PAINTING IN WATERCOLOR Mario Cooper. Van Nostrand Reinhold Co., New York. Exciting and easy to follow directions with many excellent examples.

PAINTING WITH WATERCOLOR Mario Cooper. Van Nostrand Reinhold Co., New York. Complete guide to watercolor painting, with insights into the artist's methods and work habits.

MARINE PAINTING IN WATERCOLOR Edmond J. FitzGerald. Watson Guptill Publications, New York. Excellent discussions on how and why to paint aspects of the sea. Detailed text is well done.

WATERCOLOR PAINTING STEP BY STEP Arthur L. Guptill. Watson Guptill Publications, New York. A complete and detailed book covering every facet of the medium, from paper to framing.

THE TECHNIQUE OF WATERCOLOR PAINTING Colin Hayes. Reinhold Book Corporation, New York. Lots of new and fresh ideas on watercolor and its use — mixed with other media, etc. All styles of subject matter.

WAYS WITH WATERCOLOR Ted Kautzky. Reinhold Book Corporation, New York. Watercolor painting from A to Z — complete and useful photos and text.

PAINTING TREES AND LANDSCAPES IN WATERCOLOR Ted Kautzky. Reinhold Book Corporation, New York. Direct and simple approach to painting landscapes, from sketch to the finished painting.

100 WATERCOLOR TECHNIQUES Norman Kent. Watson Guptill Publications, New York. A survey of the materials and techniques of 100 contemporary American watercolor painters.

WATERCOLORISTS AT WORK Susan E. Meyer and Norman Kent. Watson Guptill Publications, New York. Twenty-five eminent artists allow you to look over their shoulders as they paint.

HERB OLSEN'S GUIDE TO WATERCOLOR LANDSCAPE Herb Olsen. Reinhold Book Corporation, New York. All the aspects of landscapes are explored and problems solved. How to do it and why.

PAINTING THE FIGURE IN WATERCOLOR Herb Olsen. Reinhold Book Corporation, New York. How to paint from photographs, life or the model. Hundreds of professional hints.

PAINTING THE MARINE SCENE IN WATERCOLOR Herb Olsen. Reinhold Book Corporation, New York. Step by step from start to finish with sections on specific phases like waves, shore, wind, etc.

WATERCOLOR MADE EASY Herb Oslen. Reinhold Book Corporation, New York. Outline of simple procedures for painting landscapes, figures and still lifes. Considers materials, composition, techniques.

PAINTING IN WATERCOLOR John C. Pellew. Watson Guptill Publications, New York. Artist explains his own techniques and shows how to make successful paintings.

WATERCOLOR John Pike. Watson Guptill Publications, New York. Step by step how-to-do-it book for all techniques. Includes problems and solutions.

THE CONTENT OF WATERCOLOR Edward Reep. Van Nostrand Reinhold. Emphasizes content of artists' work rather than how-to-do-it techniques. For those wanting to dig into the thinking process.

FIGURE PAINTING IN WATERCOLOR Charles Reid. Watson Guptill Publications, New York. How to paint nudes and clothed figures in easy-to-do projects. Excellent design and reproductions.

WATERCOLOR PAINTING FOR THE BEGINNER Jacob Getlar Smith. Sterling Publishing Co., New York. A how-to-do-it book with many references to the master watercolor painters

LANDSCAPE PAINTING IN WATERCOLOR Zoltan Szabo. Watson Guptill Publications, New York. Discussion of methods used to achieve certain results. Many techniques in excellent detail.

WHITAKER ON WATERCOLOR Frederic Whitaker. Van Nostrand Reinhold Co., New York. Excellent guide for all aspects of the medium. Concise text, cross references, with fine illustrations.

COMPLETE GUIDE TO WATERCOLOR PAINTING Edgar A. Whitney. Watson Guptill Publications, New York. How to paint landscapes, portraits, figures, etc. in great detail. Nothing left out.

History of Watercolor

TURNER WATERCOLOURS Martin Butlin. Watson Guptill Publications, New York. Some of Turner's finest paintings and a commentary tracing the development of the artist's work.

EIGHT AMERICAN MASTERS OF WATERCOLOR Larry Curry. Praeger Publishers, New York. A catalogue of an excellent exhibit at the Los Angeles County Museum of Art.

THE WATERCOLOR DRAWINGS OF THOMAS ROWLANDSON Arthur W. Heintzelman. Watson Guptill Publishers, New York. A beautiful compilation of this master's work, with fine text and reproduction.

EAKIN'S WATERCOLORS Donelson F. Hoopes. Watson Guptill Publishers, New York. Virtually all of the artist's watercolors are reproduced and analyzed.

WINSLOW HOMER: WATERCOLORS Donelson F. Hoopes. Watson Guptill Publishers, New York. A gallery of this American master's work, with clear and lucid commentary.

SARGENT WATERCOLORS Donelson F. Hoopes. Watson Guptill Publishers, New York. Many color reproductions of these master paintings with excellent commentary.

WATERCOLOR: HISTORY AND TECHNIQUES Walter Koschatzky. McGraw-Hill, New York. Fully illustrates history of watercolor as well as an examination of techniques and methods.

THE CONTENT OF WATERCOLOR Edward Reep. Van Nostrand Reinhold Co., New York. Artist-author shows what goes into the painting besides watercolor itself. Excellent historical commentary.

CHAGALL WATERCOLORS AND GOUACHES Alfred Werner. Watson Guptill Publishers, New York. Chagall's artistic development is traced in excellent text and reproductions. Careful analysis of work.

Design and Composition

COMPOSING YOUR PAINTING Bernard Dunstan. Watson Guptill Publications, New York. How to incorporate all the design principles in exciting paintings.

COMPOSING PICTURES Donald W. Graham. Van Nostrand Reinhold Co., New York. Encyclopedic compilation of design techniques. Drawing and color are emphasized.

COMPOSITION IN ART Henry Rankin Poore. Sterling Publishing Company, New York. A fine introduction to design in painting with illustrations from the masters

A BASIC COURSE IN DESIGN Ray Prohaska. Van Nostrand Reinhold Co., New York. All the elements and principles of design and composition are handled. Hundreds of student examples.

COMPOSITION IN LANDSCAPE AND STILL LIFE Ernest W. Watson. Watson Guptill Publications, New York. Analyzes over 100 paintings and helps understand pictorial design.

Color

THE ELEMENTS OF COLOR Faber Birren, editor. Van Nostrand Reinhold Co., New York. Discusses Itten's color theories and has practical advice on mixing and special effects.

COLOR: A COMPLETE GUIDE FOR ARTISTS Ralph Fabri. Watson Guptill Publications, New York. A practical guide to the fundamentals of using color in all kinds of painting.

COLOR MIXING BY NUMBERS Alfred Hickenthier. Van Nostrand Reinhold Co., New York. A new method of identifying colors and an excellent approach to mixing. Very interesting approach to color.

COLOR EXERCISES FOR THE PAINTER Lucia A. Salemme. Watson Guptill Publications, Inc., New York. Practical help in using color in paintings. Problems and solutions using all types of subject matter.

INDEX

A

Abstraction 32, 67, 96
Abstract shapes 56, 75
Acrylic 14, 40G
American Watercolor Society 12, 123
Animals 94, 95
Approach to watercolor 8
Aquarelle 11, 17
Armstrong, Roger 14, 40D
Assignments 118, 119
Audubon, John James 94
Austin, Phil 15, 40E, 84

B

Basic techniques 46, 50
Batt, Miles G. 40A, 40C, 79
Birds 94, 95
Blake, William 11
Blotting 65, 87
Books 124, 125
Brandt, Rex 62
Braque, George 115
Bridging 32, 94
Brigante, Nick 96, 108, 112
Brommer, Gerald F. 2, 8, 17, 33, 40G, 58, 63, 73, 78, 82, 83, 86, 87, 90, 99, 100, 101, 113, 120, 127
Brushes 18, 49, 57, 65
Buel, Hubert 40H, 63, 84, 86
Buildings 91
Burchfield, Charles 10, 11
Byzantine 11

C

California National Watercolor Society 12, 123
Calligraphy 36, 45, 55, 87
Cassatt, Mary 56
Center of interest 31, 43
Cezanne, Paul 11, 98
Charging the color 40
Chiaroscuro 39
Clouds 80
Collage 72, 99, 109, 113, 116
Color 40ff
Color wheel 40, 41
Communication 12
Composition 28
Contrasting color 40G
Contour lines 29, 89
Corrections 65
Crayon, wax 66
Crown, Keith 114
Cubism 29

D

de Erdely, Francis 31
Delacroix 11
Demuth, Charles 11, 28
Design 28ff
Design concepts 32
Dike, Phil 13, 30, 97

Drybrush 54, 104
Drybrush glaze 40D, 54, 111
Dubuffet, Jean 35
Dufy, Raoul 55
Durer, Albrecht 11

E

Egypt 11
Emphasis 43
English watercolor 11
Etruscans 11
Experimentation 26, 65, 67, 68, 78, 96, 108, 116
Expressionists 11

F

Feininger, Lyonel 11
Films on watercolor 122
Finders 105
Fon, Jade 52, 104
Framing watercolors 121
Frisket 76

G

Gesso 59, 78, 119
Gibson, George 76, 86, 104
Glass 121
Glazes 53, 112
Glue, PVA 30, 64, 68, 72, 78, 113, 116
Golden, Rolland 40B, 42, 70
Gouache 70, 71, 72
Graying colors 40, 40C, 50
Green, Michael 14, 52
Guercino, Giovanni 11
Gum arabic 21

H

Haiku 103
Half pans 21
Hammons, Verily 97
Hard edge painting 97
Helps in painting 80ff
High keyed colors 39, 40H, 90
Hills 86
History of watercolor 11
Homer, Winslow 10
Hulett, Ralph 14, 91

I

Imagination 102
Impressionists 11
India Ink 75, 112
Inks 75
Intense color 40A

J

Jacobsen, Ray 16
Jones, Win 40E, 61, 111

K

Klee, Paul 103

L

LaCom, Diane 107
LaCom, Wayne 49, 76
Lifting color 65, 117

Limited palette 40C, 40D, 46, 117
Line 36, 37, 54
Location painting 105
Low keyed colors 39, 40H
Luitjens, Helen 35, 48, 59

M

Marin, John 11, 34
Marxhausen, Reinhold 16
Maskoid 76, 111
Mason, Harold 59, 122
Materials 18, 26
Matting 121
Mixing trays 25
Models 107
Motivation 8
Mountains 86
Movement 43, 44

N

Nara Period 11
Nepote, Alexander 73, 116

O

Olsen, Herb 40C, 45, 88
Opaque watercolor 17, 70
Opaque white 42, 70, 97
Orient 11
Owen, Perry A. 92, 97

P

Paints, watercolor 20, 21
Palette 20, 21, 25
Papers 22
Parshall, Douglass 12, 81
Pattern 30, 80, 91, 92, 105
Pennell, Joseph 78
People 88
Photographs 98
Plasticity 115
Poetry 102
Pointillism 12, 40G, 107
Pop Art 72
Porter, Al 12, 40G, 77
Porter, Katherine Page 106
Post Impressionists 11
Prendergast, Maurice 11

R

Rebert, Jo Liefeld 37, 40A, 56, 89, 93, 115
Rembrandt 11, 43
Renaissance 11
Resists 66
Rice paper 72, 113
Rocks 87
Roman 11
Rouault, Georges 11
Rubber cement 72, 76

S

Sandby, Paul 11
Sargent, John Singer 11
Scrubbing 40G, 53, 59, 78, 81, 117
Selectivity 80, 107
Shadows 53, 87, 91, 92

Sheets, Millard 12, 40F, 80
Shubin, Morris J. 38, 40F, 117
Signing watercolors 121
Simplify 50, 67, 83, 85, 86, 89, 91, 92, 95, 98, 105
Sizing on paper 22
Sketchbooks 101
Skies 80, 91
Slides 50, 98
Soaking 60
Societies, watercolor 12
Souza, Paul 60, 67, 96
Space division 31
Spatter watercolor 64, 65, 70
Sponge 26, 61, 63, 65, 78, 82, 86, 117
Stains 75
Starch 68
Still lifes 92, 107
Stop outs 76, 111
Style in painting 12, 29, 35
Subject matter 98
Sumi-e painting 11, 36
Surfaces, painting 26

T
Teague, Donald 7, 90
Texture 72, 75, 77, 78, 86, 91, 113
Thumbnail sketches 50
Tiepelo 11, 47
Tissue paper 75
Tools 18, 26
Transparency 14, 57, 59, 110, 111, 117
Travel exhibits 123
Trees 70, 85
Turner, William 11
Turpentine 68, 69

U
Underpainting 62

V
Values 39, 50
Value contrast 40G, 42, 45, 47, 57, 70, 92
Variety 31
Varnish 121

W
Water 83
Watercolor combinations 66ff, 78
Water containers 25
Washes 46, 49, 53, 80, 93
Wash drawing 46
Wax 66
Wessinger, T. R. 74
Weiss, Lee 40H, 110
Wet-in-wet, 54, 60, 62, 80, 101
Whitaker, Eileen Monaghan 9, 55, 95
Whitaker, Frederic 40B, 82, 105
White of the paper 59
White tempera 70
Wong, Tyrus 36, 44, 87
Wood, Robert E. 4, 16, 18, 21, 29, 30, 32, 33, 38, 39, 40A, 40D, 43, 50, 52, 53, 54, 65, 81, 85, 100, 105
Woodcock, Francis 82
Wyeth, Andrew 6

Z
Zorach, William 61
Zornes, Milford 58, 80

Ponte Vecchio. Gerald F. Brommer, watercolor, 22 x 30. The rough and mottled texture of this fascinating bridge across the Arno River in Florence was the starting point for this work. An attempt was made to show the ravages of time and the influences of man for several centuries on the structure.

ACKNOWLEDGMENTS

This book is really the combined effort of a lot of interested individuals. Teachers, artists and museum people wanted to help get the watercolor message across to America's young artists and their teachers. Their help and cooperation are deeply appreciated.

I really enjoyed the hours in other teachers' classrooms, talking and looking through stacks of student work. It is marvelous how proud art teachers are of their students' accomplishments. My sincere thanks to some excellent teachers: Jim Burke at John Marshall in Los Angeles, Grace Garcia at Hollywood High, Joe Gatto at Granada Hills High, Gene Gill at Reseda High, Shirley Godfrey at Leuzinger High in Hawthorne, Tom Nielsen at Birmingham High in Van Nuys, Rene Parola at John Marshall in Los Angeles and Ted Wessinger at Gardena High School — all in California.

Many fine watercolorists helped fill the pages of this book with their excellent work, many of them prizewinning paintings. They responded in marvelous fashion to my call for help, even though some are working on books of their own. Some have books already on the market. All are superb painters and their contributions should help clarify some points made in the book. My heartfelt thanks to Roger Armstrong, Phil Austin, Miles Batt, Nick Brigante, Hubert Buel, Keith Crown, Phil Dike, Jade Fon, George Gibson, Rolland Golden, Mike Green, Verily Hammons, Ralph Hulett, Ray Jacobsen, Win Jones, Mary Jane Kieffer, Diane and Wayne LaCom, Harold Mason, Alex Nepote, Herb Olsen, Perry Owen, Douglass Parshall, Al Porter, Katherine Page Porter, Jo Liefeld Rebert, Millard Sheets, Morris Shubin, Paul Souza, Donald Teague, Lee Weiss, Eileen Monahan Whitaker, Frederic Whitaker, Tyrus Wong, Robert E. Wood, Francis Woodcock, and Milford Zornes. They live all over the United States, but have brought their work together for you in one place, to see, enjoy and experience.

Other people were gracious in their help, particularly Elinore Cytron, Sheldon Ehrlich and Charles Weisenberg at the Los Angeles County Museum of Art. Thanks also to Mrs. Ruth Hatfield at the Dalzell Hatfield Galleries and to R. P. Marxhausen at Concordia College in Seward, Nebraska.

Many thanks also to George Horn who is a master at dropping subtle hints about getting to work. And certainly a final thank you to my wife, Georgia, without whose patience and understanding deadlines would never be met.

GFB